# the KODAK Workshop Series

# Advanced Black-and-White Photography

## the KODAK Workshop Series

*Helping to expand your understanding of photography*

### Advanced Black-and-White Photography

Written for Kodak by Martin L. Taylor,
Owen Butler, and Hubert Birnbaum.

Kodak Editor: Martin L. Taylor

Book Design: Martin L. Taylor and Donald Malczewski

Technical Consultant: John Sexton

Cover Design: Martin L. Taylor

Cover Photograph: Tom Beelmann

Picture Research: William S. Paris

Photographic Products Group
Eastman Kodak Company
Rochester, New York 14650

KODAK Publication KW-19
CAT 144 1849
Library of Congress Catalog Card Number 83-81296
ISBN 0-87985-324-7
1-88-CX Major Revision
Printed in the United States of America

*The Kodak materials described in this book are available from those dealers normally supplying Kodak products. Other materials may be used, but equivalent results may not be obtained.*

# Advanced Black-and-White Photography

# Contents

*Eugene Atget photographed early 20th century Paris with a devotion seldom shown any other subject by any other artist. Atget is perhaps unique in photographic history because of his isolation from other photo artists. He was, however, well acquainted with current Parisian artists and their followers. His remarkable, extensive body of work shows aesthetic sensitivity and a timelessness that still retains a strong documentary value. Many others will be remembered for their verbal comments about photography—Atget will remembered for his photographs.*

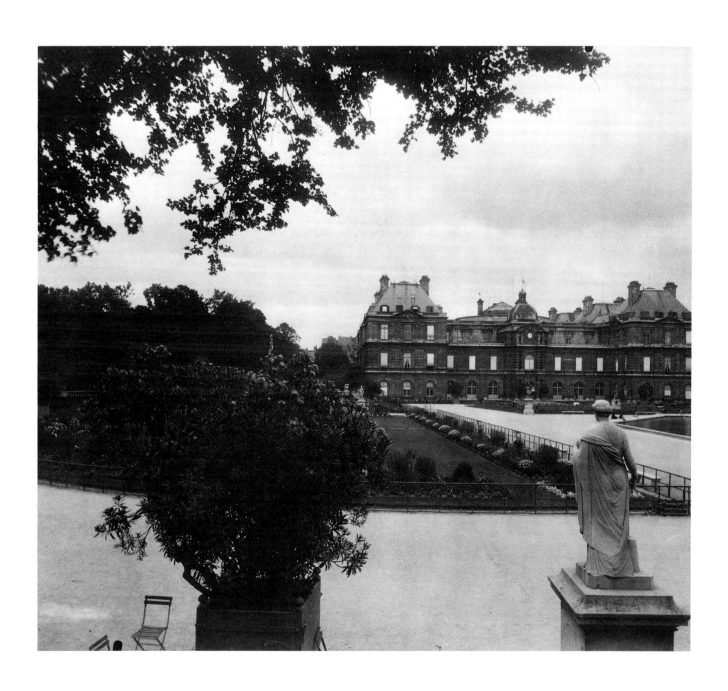

# Introduction

*Black-and-white photography is a unique artistic medium. Its images are abstract—they often represent, but never duplicate the real world. Colors are shown in gradations of gray tones, expanded or compressed. And, of course, prints are two-dimensional. But what appears to be a limitation is actually a greater freedom to interpret the universe.*

*Black-and-white photography is a language of the senses. Viewing a black-and-white photograph provides a sensual experience that defies verbal description. It is intensely personal and depends for effect on the psychology, culture, and experience of the viewer, which may be vastly different from those of other viewers or of the photographer himself.*

*The spoken language is an imprecise and inadequate vehicle for conceiving or conveying universal truths about photography, if indeed there are any. Any philosophical discourse that seeks to judge, define, evaluate, or categorize photography should be approached skeptically.*

*The purpose of this book is to offer an enhanced experience with fine photography. It first presents some of the possibilities for dramatic expression in this popular medium. It then offers sophisticated techniques for gaining precise and consistent results.*

*Ansel Adams is often credited as the technical master of his century. Large-format negatives tested, exposed, and processed according to meticulous procedures resulted in magnificent drama such as the scene at right. For all the logical theory and precise laboratory techniques, it's easy to forget that Adams was indefatigable in finding powerful scenes and subjects and then waiting for the very best conditions to capture them. Strong, emotional printing completes his list of outstanding achievements.*

Ansel Adams, "Half Dome, Clouds, Winter, Yosemite Valley." Courtesy of the Ansel Adams Publishing Rights Trust. All rights reserved.

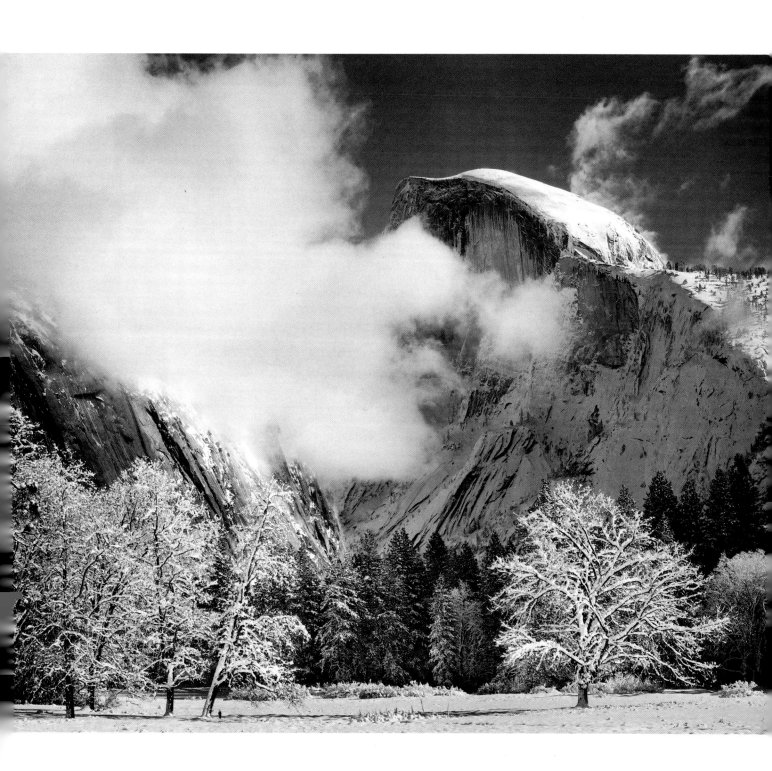

# History

The history of monochrome photography includes two intertwined histories. One important vine is the evolution of processes and techniques that improved the efficiency and quality of image-making. The other vine is the evolution of the philosophy and rationale of photography as a fine art. In the early years when each renowned photographer also contributed to the science of the photographic process, the two chronologies were inseparable. But after several decades a natural rift appeared. The scientists aimed their efforts at improving technology, and the philosophers bent their energies toward the content of, and the reasons for, the final image.

In the illustration on page 9 you will see authentic examples of key steps on the ladder toward better, easier picture making. You can correlate most of these examples with the short descriptions on pages 9 and 10 of what made the new processes better. The following pages highlight some of the twists and turns that occurred in the thinking of photo-artists.

## TECHNOLOGY

From the middle of the eighteenth century painters had tried to create ever more precise, realistic images on their canvases. The time was ripe for the discovery of the photographic process. All of the elements were available. The *camera obscura* had been a familiar artist's tool since da Vinci's time. It projected an image from a pinhole onto a wall where it could be traced. Later a lens projected the image onto a groundglass.

In the 1600's, an Italian scientist, Angelo Sala, discovered that sunlight turned silver nitrate black. One hundred years later Professor Johann Schulze accidentally applied this phenomenon by exposing a container of silver nitrate to sunlight. The area that received direct sunlight turned dark, while the unexposed area remained white. After confirming that light, rather than heat, made the image, Schulze continued to make silhouette images with his magical substance. The problem that plagued him continued to thwart the progress of photography in its infancy—the exposed image disappeared rapidly.

Nearly another hundred years passed (1802) before Thomas Wedgewood began a series of experiments aimed at creating a convenient mechanical substitute for the tedious, and presumably expensive, practice of handpainting intricate patterns on chinaware. By sensitizing white paper or leather and exposing it to light so as to project a pattern silhouette, Wedgewood indeed made images. The still unsolved problem was that the silver nitrate negative sunprints faded in the presence of light.

Ironically, although all previously successful research into photographic imaging and most subsequent photographic processes involved silver salts and their unique light-sensitive properties, the first stable photograph was created by a lithographer with non-silver materials. Joseph Nicéphore Niépce, in searching for a way to reproduce images more easily on his stone masters, invented photography with asphalt, oil, and a pewter plate. Thus began 150 years of thrilling artistic and scientific exploration.

Back row, *l-r: anon., Untitled (portrait of a woman), no date, salted paper print; W. Stillman, "Temple of Victory," n.d., carbon print; anon., "Edwin Forrest," n.d., photogravure.*

Center row, *l-r: Elijah Walton, "English Lake Scenery," 1876, album illustrated with platinum prints; anon., "East End, York Minster," n.d., albumen print; anon., untitled (portrait of two children), n.d., hand-tinted tintype; anon., untitled (portrait of two women), n.d., hand-tinted tintype; anon., "Nave, York Minster," n.d., albumen print; S.H. Davis, untitled (portrait of a group of children), n.d., hand-colored tintype; anon., untitled (fisherman—circular format), n.d., snapshot from early Kodak camera; G.F. Gates, "Syracuse and Surroundings," n.d., stereo card; Huested & Norton, untitled (portrait of young woman), n.d., albumen print; Hennigar Bros., "Cornell University—Graduation Dresses," c. 1880, albumen print; Tom Beelmann, "Steps," 1974, silver print;*

Front row: *anon., untitled (portrait of woman), n.d., hand tinted daguerrotype; anon., untitled (portrait of girl, n.d., ambrotype.*

*"n.d."—no date*
*"anon"—anonymous*

## DISCOVERIES

The following chronology touches some of the key points of discovery in the science of photography. Each landmark significantly improved either the image or the photographer's task in making the image. Many important steps are missing, including advances in lens design, enlarging, and others that have improved the photographer's ability to capture the evanescent images of everyday life.

*1826, Joseph Nicéphore Niépce* (French): Created a positive image on an acid-etched plate. Bitumen of Judea (asphalt) hardened with exposure to sunlight. Unexposed areas remained soft and were removed by a lavender oil bath. The plate was then bathed in acid to etch out the midtone and shadow areas.

*1839, Louis Daguerre* (French): Collaborated with Niépce and worked after Niépce's death in 1833 on a photographic system that provided a positive original—the daguerreotype. A silver-covered copper plate was sensitized before exposure with iodine

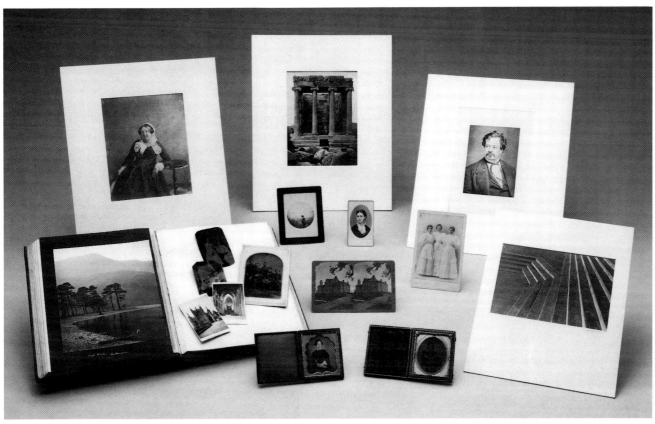

Still life by Tom Beelmann; subjects kindly loaned by the Visual Studies Workshop of Rochester, New York.

vapor. The resulting silver iodide captured a latent image during exposure. The plate was developed by mercury vapor, which formed a mercury-silver amalgam on the exposed portions of the plate. The plate was actually a negative. By holding the plate so that the unexposed mirror-like silver reflected a dark color, the image would appear positive. Shadows occurred during fixing where hyposulfite of soda removed the silverplate not affected by exposure, revealing the dark, polished metal underneath. Daguerre quickly discovered the principle of the latent image which enabled practical exposure times for many subjects. The main disadvantage of the brilliantly sharp image was that it couldn't be reproduced—the original was the only image.

*1833-1839, William Henry Fox Talbot* (English): Independently discovered a photographic method that offered the means for multiple copies from the original negative image. Frustated at first with the impermanence of the image, Talbot was introduced to sodium thiosulfate by Sir John Herschel. Talbot's calotypes were negatives made on paper using a silver-iodide emulsion. Contact-printed with another sheet of sensitive paper, the image became a positive paper print. Talbot also discovered the latent image and shortened camera exposure times dramatically. The advantage of the calotype was its ability to be contact printed for any number of positive prints. The paper negative, however, offered a softer image than the daguerreotype.

*1847, Abel Niépce de Saint-Victor* (French): Invented the first practical dry-plate negative. By suspending light-sensitive material in an albumen (egg white) medium, he successfully coated glass plates. The dry plates could be exposed in the field and processed in the laboratory. His glass plates combined the sharpness of a daguerreotype and the reproductive abilities of the calotype. The glass, unfortunately, was too heavy to transport conveniently.

*1850, Louis Désiré Blanquart-Evard* (French): Created a printing paper with an albumen emulsion. With few significant advances over the calotype paper, it never became very popular.

*1851, Robert Bingham* (English): Discovered the collodion (wet plate) process. A glass plate was covered with liquid gun cotton (cellulose nitrate dissolved in a solution of ether and alcohol) and then sensitized in silver nitrate. The plate was exposed while still wet from the sensitizer and developed immediately in pyrogallic acid. Although involved, the process offered short (5-second) exposures with a fresh plate. The emulsion dried after processing to a tough skin that could be removed whole from the glass plate, which could then be reused, thereby lightening the photographic field kit. The negative image was contact printed to make positive prints.

*1854, James Ambrose Cutting* (American): Seized on the popular knowledge that the collodion plate could be used as a positive image when backed by a dark cloth or when the back was painted black (Ambrotype).

Patented his idea in America. The collodion image was gray (highlight) which contrasted with the clear glass backed with black (shadow).

*1854, Adolphe Eugène Disdéri (French):* Using a camera with multiple lenses created the rage of "carte de visite" photographs that could exhibit up to eight poses on the same collodion plate. The positive print could be cut up into separate 2 1/2 X 4-inch photos.

*1856, Hannibal L. Smith (American):* Introduced the "tintype"—use of a thin metal support for the collodion original that was easier to produce, not as easily damaged, and cheaper than the daguerreotype or ambrotype. The metal plates were japanned black or dark brown. First called the melainotype by manufacturer Neff or ferrotype by manufacturer Griswold. Tintype name came later.

*1864, B. J. Sayce and W. B. Bolton (Scottish):* Made another attempt at dry plates by coating glass with collodion mixed with cadmium bromide, ammonium, and silver nitrate. The plate required longer exposures than the wet-plate method, and the weight of the plates made them cumbersome. Not as popular as the wet-plate method.

*1871, Dr. Richard Lech Maddox (English):* Substituted gelatin for collodion to avoid the odors connected with the collodion process. Also a dry-plate process.

*1878, Charles Harper Bennett (English):* Discovered how "ripening" the dry gelatin emulsion with heat increased sensitivity. Made possible the first handheld exposures.

*1887, Hannibal Goodwin (American):* Filed the patent for a photographic system using a roll of flexible film-gelatin emulsion on a transparent base of cellulose nitrate, one of the first plastics.

*1888, George Eastman (American):* Introduced the KODAK—a snapshot camera loaded with a roll of film (a roll of paper coated with a dry gelatin emulsion) that gave 100 pictures. The camera was returned to the factory after the roll was exposed. There the film was processed and the emulsion was stripped off the paper, transferred to a transparent base and printed. In 1889 Eastman converted the paper film to a transparent cellulose nitrate base. The new film could be processed by the amateur at home.

*1890, Vero Charles Driffield and Ferdinand Hurter (English):* Published research on light, exposure, emulsion sensitivity, and development to establish the basis for the science now called sensitometry. First to attempt any logical basis for determining optimum exposure and development with given emulsion characteristics.

*1930, Eastman Kodak Company (American):* Commercial introduction of "panchro" plates—sensitive to most of the visible spectrum. Previous emulsions had been insensitive to red light. Panchromatic materials gave the photographer the ability to balance tonal reproduction, increase or decrease contrast, or make dramatic changes in the tonal reproduction of the final print. The knowledge was not new. Hermann Wilhelm Vogel discovered how to sensitize plates to individual colors with dyes. Although his later plates could record most of the visible spectrum, they did not appeal to the photographers of his era because the rendition appeared too manipulative and not "realistic."

*1940, Defender Photo Supply (United States), Ilford, Ltd. (England):* Variable contrast paper is introduced. The contrast of the paper can be changed by using filters over the printing light.

*1940's, Eastman Kodak Company:* Started development of what eventually evolved into resin-coated enlarging paper. With these papers fixing and washing times are shortened because a water resistant coating over the paper base prevents fixer from reaching it. During WWII, water resistant papers for aerial mapping were produced by coating a melted cellulose derivative onto paper. Later a cellulose acetate coating was used. In the 1950's, an extrusion process using polyethylene was developed and is still used today.

*1986, Eastman Kodak Company:* KODAK T-GRAIN Emulsion introduced into two black-and-white films—KODAK T-MAX 100 and T-MAX 400 Professional Films. By reshaping the granular silver halide crystal into a tabular form, scientists were able to make extremely fine-grain emulsions in faster films.

## PHILOSOPHY

Art is a dynamic process. The established order challenges and is challenged by radical elements. Most often the old order vehemently resists the onslaught. Frequently it topples to allow the newcomer established-order status. The prolonged skirmish usually reflects the tension among conflicting world views. What seems to be radical, avant-garde, defiant, and anti-social in one epoch often becomes the conservative standard in the next, or a beloved thread in the weave of nostalgia many years hence. An uncomplicated look at the history of photographic ideas and opinions and some visual examples may help to understand current and future trends.

One of the fundamental artistic concerns seems to be the representation of an inner reality through the adaptation of a particular medium. In some periods it was thought essential to render the subject as precisely as possible. In others, interpretation of the subject became more important. In all cases, the artist was expressing a personal view frequently influenced profoundly, yet indirectly, by prevailing trends of thought within the culture.

What follows is a brief listing of a few of the better-known workers in photography and why their efforts are esteemed. This short chronology should also help to track the diffuse advances of artistic intention within the photographic community. Although some of the change can be attributed to advances in the science of photography, most of the philosophical differences can be traced to changes in or reactions against the prevailing trends of intellectual and popular culture of the period.

Several of the terms used in the list bear definition or at least explanation. They generally apply to media other than photography and will be familiar to students of the arts.

*Experiments with cameraless photography (photograms) provided a new outlet for creative energy and promoted the appreciation of non-narrative values. Many forms of non-traditional photography also gave the artist a vehicle for self expression—in this case an airy, whimsical humor.*

Lazlo Moholy-Nagy; "Self Portrait Lighting Cigarette," 1922, courtesy Hattula Moholy-Nagy and Hallmark Collections.

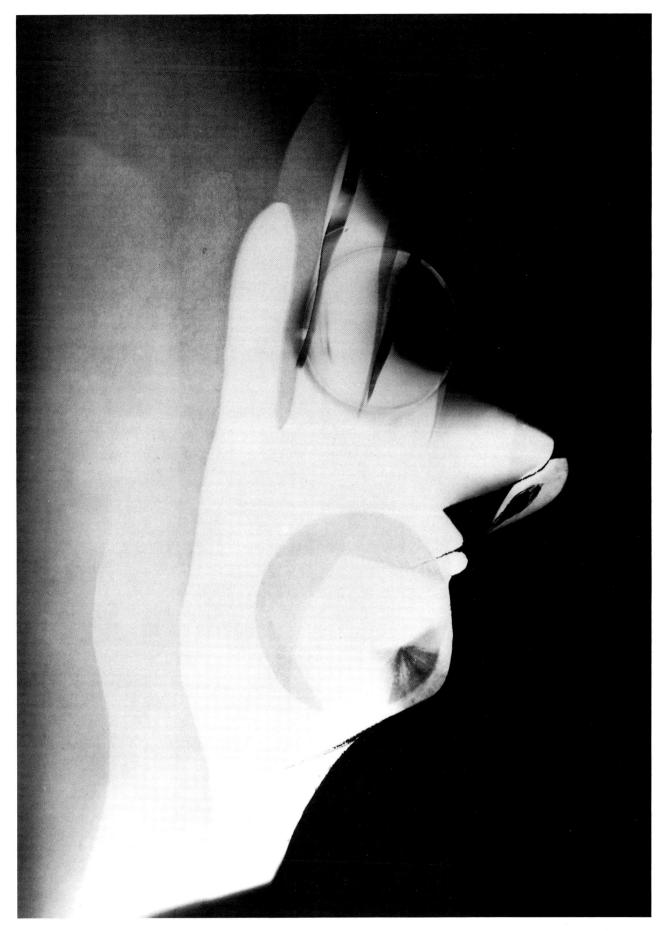

## Glossary

*Romanticism*—a reaction against Descartes, Locke, and the Age of Reason. Emphasis on emotion, fancy, and whim. Glorification of the real and fascination with what may exist behind appearance.

*Pictorialism*—a school of photography dominated by the assertion that photography was high art equal to, but different from, painting of the period. Subject matter was the same as the painting of the day—usually Romantic—such as portraits, landscapes, and allegory. Photographic techniques were used to achieve soft focus and moody lighting that characterized popular painting.

*Purism*—the notion that photography should be used in a way that allowed the assertion of photography's unique properties. Emphasized fidelity to the subject as seen by the photographer with a sharp lens and accurate process control. The photo is made without manipulation and preferably contact printed to transform the subject point-for-point onto the picture plane.

*Formalist*—one who portrays the appearance without the substance of a subject. A photographer who is concerned with the unique and inherent qualities of the photograph—his image becomes a statement about photography rather than about the subject. An attitude rather than a trend.

*Equivalents*—Stieglitz' notion that familiar subjects can be viewed as "equivalents" of emotions, moods, and feelings within a photograph. A Stieglitz cloud picture is more than a cloud. It is a metaphor for an emotional or intellectual experience.

*Expressive*—portraying the artist's personal feelings about the subject.

*Abstract Expressionism*—a movement in painting during the 1950's that conceived the canvas to be a field for an artist's action, gestures, and raw emotions. Characterized by little or no reference to real world subjects and situations. Trend appeared in photography—the print became the field for an artist's outpourings.

## Artists

*William Henry Fox Talbot* (1800-1877, English): (With Sir John Herschel discovered properties of sodium thiosulfite—hypo—as image stabilizer.) Used photography to eliminate tedium of drawing. Subscribed to Dutch School of painting which honored the familiar, mundane, and overlooked.

*Albert S. Southworth* (1811-1844, American) and *Josiah J. Hawes* (1808-1901, American): Daguerreotypists in Boston who made excellent portraits with creative uses of lighting and props.

*David Octavius Hill* (1802-1870, Scottish) and *Robert R. Adamson* (1821-1848 Scottish): Made outstanding calotype portraits that showed powerful characterization, a masterly sense of form, and a sure instinct for bold, simple composition.

*Francis Frith* (1822-1898, English): Best known for his documentary photographs of the Middle East, which captured landmarks, historic sites, and landscapes. Often used 16 x 20-inch glass-plate negatives.

*Carleton Watkins* (1829-1916, American): Depicted Romantic ideas in San Francisco and western landscapes. His photographs were popular and sold well.

*Timothy O'Sullivan* (1840-1882, American): Documented unseen western America for government. Informational approach a polar extreme from Watkins, but his powerful images far exceed mere documents.

*Julia Margaret Cameron* (1815-1879, English): Made expressive portraits and allegorical images. Allegorical efforts' not as believable or as memorable as portraits.

*Oscar Gustave Rejlander* (1826-1875, English): A pictorialist with high art pretension. His work shows unusual attention paid to psychological rather than visible realities. Used multiple exposure and printing to achieve effects.

*Henry Peach Emerson* (1830-1901, English): A pictorialist with high art pretension. Tried to popularize photography by imitating popular genre studies common to the painting and engraving of the period.

*Peter Henry Robinson* (1856-1936, English): A pictorialist who attempted to base photographic artistic pretension on scientific theory. In fact, he derived his model from painting rather than science or ideas of previous photographic pictorialists.

*Frederick Evans* (1853-1943, English): A purist who concentrated on the expressive powers of light and architecture.

*Eugene Atget* (1856-1927, French): Photographed the streets of old Paris extensively. Isolated from the photographic mainstream of his day, Atget worked alone, but his sensitivity to form and expressive content and subtle interest in the vernacular make his work a major concern of contemporary image makers.

*Lewis Hine* (1874-1940, American): Trained as a sociologist, Hine became famous for his documentary photographs of immigrants landing at Ellis Island and of children working in factories--these latter photos were vital in establishing child labor laws. Also photographed the day-to-day construction of the Empire State Building.

*Edward Steichen* (1879-1973, American): An exemplar of pictorialist ideals whose work included commercial and war photography as well as portraiture, still life, and landscape. He culminated his career as curator of the Museum of Modern Art in New York City with the "Family of Man" exhibition.

*Alfred Stieglitz* (1864-1946, American): Although he began as a pictorialist, he later turned to "equivalents"—the notion that photographs can express abstract emotions. Later his work evolved into purism, espousing the principles of the fine print.

*Alvin Langdon Coburn* (1882-1966, American in England): Started as a pictorialist but later adopted modernist concepts such as abstraction and the ambiguous picture plane from avant-garde movements in the plastic arts, applying them to photography.

*Paul Strand* (1890-1976, American): With Coburn and Stieglitz was first concerned with the formal characteristics unique to photography—purism. He also adopted modernist ideas in the visual arts. Later he shifted his interest toward mundane, everyday subject matter,

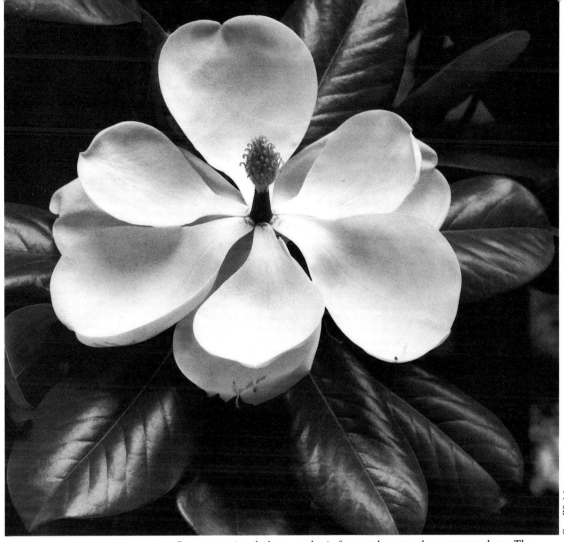

Gary Whelpley

*Representational photography is frequently more than content alone. The lush interplay of tones in this flower portrait give it dimension that extends far beyond a purely descriptive image.*

away from "art photography" subject matter that was removed from reality or romanticized.

*André Kertész* (1894-1985, Hungarian): Created first published photo essay (of peasants in Hungary). Also applied surrealist notions to his personally expressive photography.

*Edward Weston* (1886-1958, American): One of the foremost spokesmen for purist ideas. Renowned for needle-sharp views of nature subjects made with large-format tools.

*Ansel Adams* (1902-1984, American): Leading purist landscape photographer of his time—glorification of nature and the big scene. Precise camerawork and process characterize his working methods.

*Aaron Siskind* (1903- , American): Applied Abstract Expressionist principles to photography. Sought to create symbols and images of greater meaning than the subjects themselves.

*Lázló Moholy Nagy* (1895-1947, Hungarian): Applied design concepts to photography. Saw photography as a way to portray the world visually for everyone. Incorporated photography with other graphic arts (such as collage) for the mass media.

*Man Ray* (1890-1976, American): Through use of solarization, reverse printing, and photograms brought surrealism to photography with unexpected juxtapositions, ambiguity, contradiction, and paradox.

*Minor White* (1908-1976, American): Extended Stieglitz' equivalents concept. Attempted to use photography as a personal mythicopoetic tool to discover truths within himself and in his environment.

*Harry Callahan* (1912- , American): Pursued the formal potential of photography. Like Moholy-Nagy, interested in design concepts and the graphic qualites innate to photography.

*Gyula Halász Brassaï* (1899-1984, Hungarian): Depicted nightlife of Paris in the 1930's. Emphasis is on the subject—photographer is an independent observer. Captured fleeting expressions and gestures to express universal truths.

*Henri Cartier-Bresson* (1908- , French): Master of the candid photograph. Sought to capture the "decisive moment" when relationships of people and other elements in the scene provided the most information. Self-styled photojournalist.

*Robert Frank* (1924- , Swiss): Emphasized content over form. Freed the photographer to explore the social landscape in a more relaxed manner. Capitalized on serendipitous, "corner of the eye" revelations.

*Dorothea Lange* (1895-1966, American): Expressive documentarian. Photographed people struggling for survival to implement reform. Portrayed subjects as archetypes.

*Walker Evans* (1903-1975, American): Examined commonplace subject matter and attempted to define the American social landscape through exploration of the vernacular. A formalist.

13

# Gallery

*Photography portrays. It depicts the environment and the elements that reside within. As the tools have advanced, so has the ability of photography to explore our surroundings. The passage of time has established some fairly arbitrary divisions of photographic content. These different themes provide, in sum, the reasons that people take photographs and the reasons that people view photographs. The common areas of interest include landscape, portrait, candid, photojournalism, documentary, still-life, and experimental or avant-garde. Of course, there is an enormous body of work created for commercial, scientific, and industrial purposes, but those are beyond the scope of this book.*

*The following section will discuss the above subject areas with an eye to historical background, psychological impact, and methods of subject treatment. Naturally, the effects of monochrome rendition will be important here as will general considerations of tools and techniques.*

*This section is meant to provoke and inspire rather than instruct. It hopes to start your creative energy flowing in a broad variety of photographic directions and to open your eyes with examples of fine monochrome photography.*

*An artist's vision reaches farther than that of his fellow man. It may inspire subjects, tools, and techniques never attempted or conceived. It may convey visual impressions never before experienced. Here, Frederick Sommer has created a subject (by painting cellophane) and then photographed it. The result is unique and augments tradition by transferring the title of "piece of art" to the photograph from the also-created subject.*

Frederick Sommer, "Paracelsus," 1959; print courtesy of the Center for Creative Photography, University of Arizona

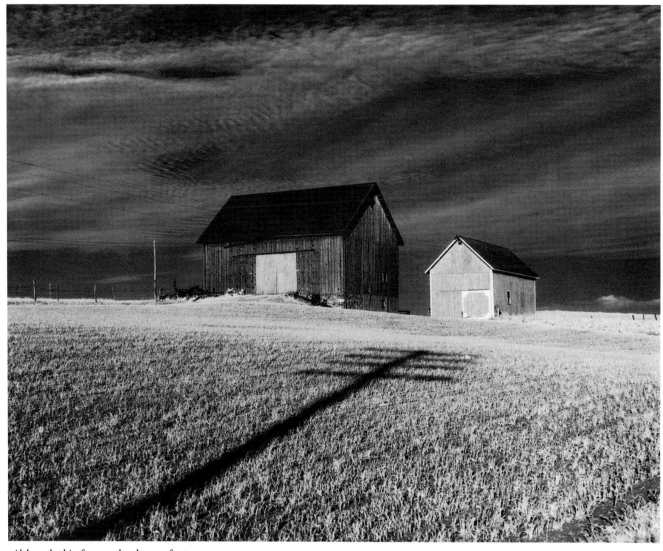

*Although this famous landscape features not one but two barns, it is scarcely a cliché. The powerful diagonal shadow of the utility pole, the fainter interplay of subtle, smaller diagonal lines, and the dramatic contrast between foreground stubble and mackerel sky combine for impact that arrests the viewer's attention. White's incomparable eye and precise camerawork transform a banal scenic into a compelling environmental statement.*

Minor White, "Two Barns and a Shadow," 1955, Minor White Archives, Princeton University

## LANDSCAPE

The word landscape has lost its meaning through overwork. Everyone knows what a landscape is. The common image that comes to mind is the red barn in the perfect autumn setting or the covered bridge with a light dusting of snow. Most photographers would agree that the landscape is considerably broader than this rather confined view. Perhaps portrait of the environment would be a better description. If the portrait of the environment includes more than red barns and covered bridges, what else might fit? Obviously, mountains, beaches, deserts, forests, cities, standing water, villages, running water, or industry can all fit into a larger assessment of landscape possibilities. (We'll continue to say landscape for simplicity.) Whether man is involved or not makes little difference. It's really the larger view of things that makes the landscape.

Making a monochrome image of the environment creates a magical view. It is a view that no one can ever see. It is an abstract look that concentrates on elements hidden within the scene. It has the ability to reduce a scene to fundamental issues. Without color constantly nagging about reality, a viewer is free to assess the structure of the scene. Interplay of light and dark areas (chiaroscuro), sharp or gentle delineation of boundaries, expression of texture and patterns, and simple definition of form all awake the viewer to more than the face value of a scene.

Cézanne attempted to reduce forms to geometric shapes, reminding us of Plato's search for ideal figures. By stripping a scene to its essentials, monochrome photography provides a similar method for generalizing specific information and thereby touching a greater audience. Moreover, the artist can control the monochrome outcome of the scene (and the effect) far beyond what first appears to his or her eyes. The monochrome landscape springs from the photographer's imagination—beginning with the framing of the scene and ending with the finishing of the print.

In the dim beginnings of photography (monochrome, of course), the greatest attention was paid to the mere faithful recording of seemingly impossible details. After the wonder of photography's accuracy faded, it was replaced by the excitement of seeing reproductions of storybook scenes taken by ambitious travelers in obscure corners of the world. And then there was the fascination of viewing scenes constructed by the artist that represented familiar stories, often biblical or morality tales. In time, the photographer separated himself from standards created for other media, and in doing so, became an artist. The mind and eye behind the camera could now concentrate on the uniquely individual view translated through technique into a print.

*Soon after the refinement of practical photography, the wonder of photographic accuracy was supplanted by wonder of strange sights recorded throughout the world. Photography's first assignment was to bring faraway places back to the hearths of armchair travelers. Notice how Frith was able to establish the size and distance of the first pyramid with two groups of figures and the diagonal line of footsteps. This information would have been extremely helpful to his audience.*

Francis Frith, "The Pyramids of Dahshur, Egypt," 1858, International Museum of Photography

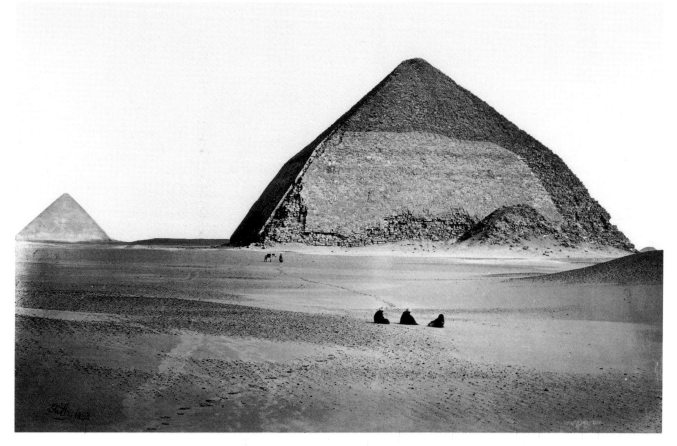

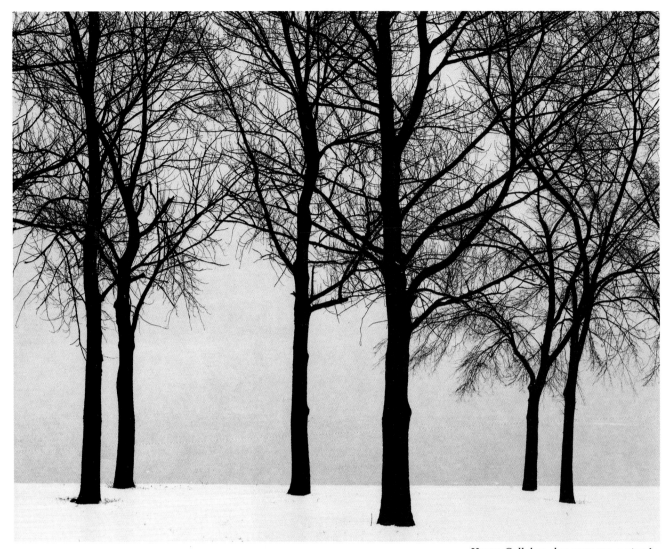

*Harry Callahan demonstrates a simple, graphic approach to landscape representation that emphasizes the appearance of winter with a few strong elements in a limited number of tones.*

Harry Callahan, "Chicago, 1950;" courtesy: Pace/MacGill, New York

People disagree on nearly everything, particularly what is artistically valuable. This rich lack of accord has given audiences of the late 20th century a wealth of monochrome landscape styles, motifs, and, of course, images. From the magnificent platinum prints of Peter Henry Emerson to the stark images of Harry Callahan, there is an entire universe of landscape photographs to appreciate and learn from. One of the best ways to help define one's own landscape view is to spend time pouring over books and reproductions of the last 150 years of photography.

Finding and photographing your own stimulating monochrome landscapes requires practice in looking and practice in using the medium. There is one aid that can help the looking, a KODAK WRATTEN Gelatin Filter, No. 90, which reduces a scene to monochromatic tones. But with experience, looking and seeing soon become automatic. Then you have to refer to your visual ideals and prejudices to find the scenes that you want to create.

Organizing the elements of a landscape scene for photography requires attention to lighting, viewpoint, and

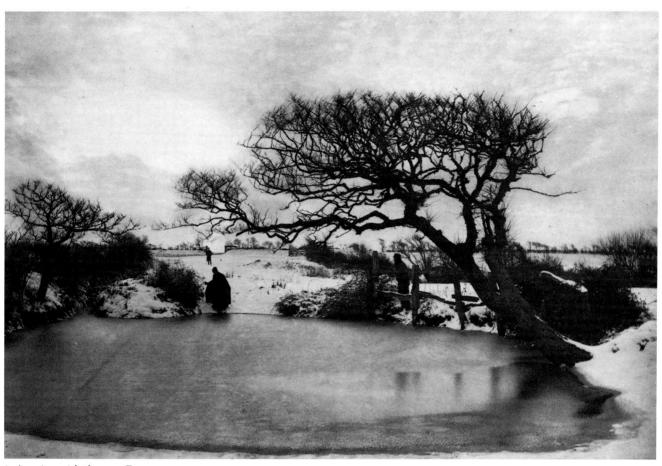

*In keeping with the era, Emerson portrayed his winter scene with a complex interrelationship of subject and tonal elements. One of the early and controversial proponents of photography as an "Art", Emerson nevertheless contributed greatly to the field by offering sound, practical advice and by inspiring decades of heated dialogue.*

Peter Henry Emerson, "Pond in Winter," 1888, International Museum of Photography

viewfinder cropping. Trying to project how a provocative view will appear in black and white may help to focus your thoughts about composition. Most of the pictorial tools described on pages 34-45, such as chiaroscuro, contrast, key, lines, shapes, form, and texture all contribute to the environmental photograph.

Craft is important in landscape photography. The section beginning on page 48 will help you discover a set of guidelines that will assist you in taking the black-and-white landscapes you have seen with your imagination. Most important is consistency. Choose one film with attributes that appeal to you; become complete-

ly familiar with its exposure and processing characteristics, and practice printing those controlled negatives. You will be well on your way to photographing what you want to see.

Certainly, experimenting can be valuable, and some will be necessary in the beginning to determine what emulsions and procedures work best for you. Optional control such as filtration and special function films may help in arriving at your desired goal, but only after you understand how the foundation pieces fit together.

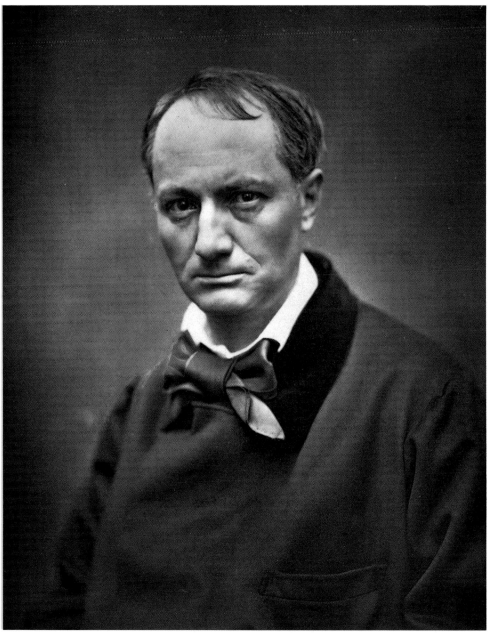

Etienne Carjat, "Charles Baudelaire," © 1863, International Museum of Photography

## PEOPLE

Taking and looking at pictures of people is one of the most pervasive photographic pastimes. Although the question "Why?" seems obviously answered, a bit of investigation may open more doors than a brusque glance at the question.

People have been photographed for as long as it was practical to do so. Eight hours was too long a sitting, so Niépce shot landscapes and still lifes. But when Daguerre and, coincidentally, Fox Talbot shortened the pro-

cess, photographic portraits were available for a much larger group than painted portraits had ever been. Portraits as well as comfortable living became readily available for the middle class as well as the wealthy.

By the late 1800's portraits in many forms—ambrotypes, tintypes, and cartes de visites—were de rigeur for people of all classes and stations of life. When amateur photography became a typical household occupation, the rise in pictures of people and their activities was astounding. The likely

reasons will come as no surprise.

What makes photographs of people fascinating? First, there is the intrigue of design, which is more readily apparent with black-and-white materials. Although the human face and body are basically symmetrical, they can be bent and shaped in any number of fascinating ways. The constantly changing face is an almost totally kinetic subject that can be halted only with a photograph. Faces and bodies can provide endless design possibilities by themselves and as objects of

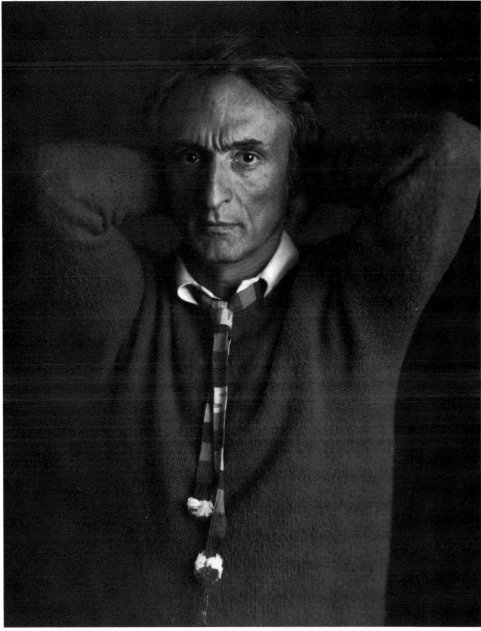

© 1981, Timothy Greenfield-Sanders, "Larry Rivers"

interest in an infinite number of environments. Faces can provide fascinating texture and patterns. Figures in light or in silhouette offer a wide variety of shape possibilities and people can reflect or contrast with elements of their surroundings.

People are also emotional subjects. We react to expressions. We lock onto the eyes staring out to us from a piece of paper. Do we seek some optimistic portent of the future in captured faces? Can we find some warmth in the two-dimensional humanity before us? Is there information about the past that stirs nostalgic feelings about periods that ended many decades before our own? Do they like us or are they indifferent, perhaps openly hostile? Can we empathize with their mood or does it touch us in some indefinable way? How are we affected by their elation, sadness, contentment, or anger?

Here we can stare without embarrassment at people we would only glance at in person. Here, despite the barrier of time, paper, and chemicals, we hope to establish contact with a person once held at the other side of the lens. We and they are permanently in limbo, much as the dancers on Keats' Grecian urn.

These photographic depictions of people hold oceans of import for us. Certainly, faces we recognize hold a definite attraction, but often the faces shielded by anonymity are equally compelling. Perhaps our lives pass too fast, and perhaps these stilled humane images offer something we rarely get in the mad swirl of everyday living. As viewers of people photos, we should perhaps pay more attention to our reactions so that as photographers we can better understand our subjects and how to treat them.

Black-and-white photography is uniquely facile at dealing with people. It tends to separate a person from a particular time. What appears in the final print may be a richer understanding of the person's character. Surroundings are less intensive.

When we look at a face, we see texture, a quality easily subdued by color. We are also impressed by the forms created by the interplay of highlight and shadow. The shape of the figure within the environmental landscape is defined in tones, simplified for an easier assessment of the situation.

The portrait (in the wider sense of the people photograph) process is controlled by the artist. The person, of course, is controlled through posing in only the most superficial sense. But the artist can vary technique and create a suitable environment.

The photographer's responsibility is manifold. He must respond to the subject's personality and provide for it appropriately. This means considering the setting, the lighting, the lens, the film, the camera-to-subject distance, the pose and, finally, the darkroom process that will determine the appearance of the final print. The photographer will record only what is already there. But, he should be poised to capture the expected and the unexpected as the subject changes expression and position.

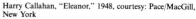

Harry Callahan, "Eleanor," 1948, courtesy: Pace/MacGill, New York

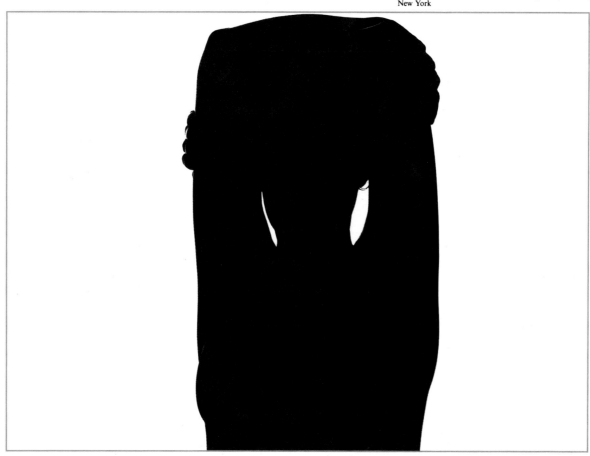

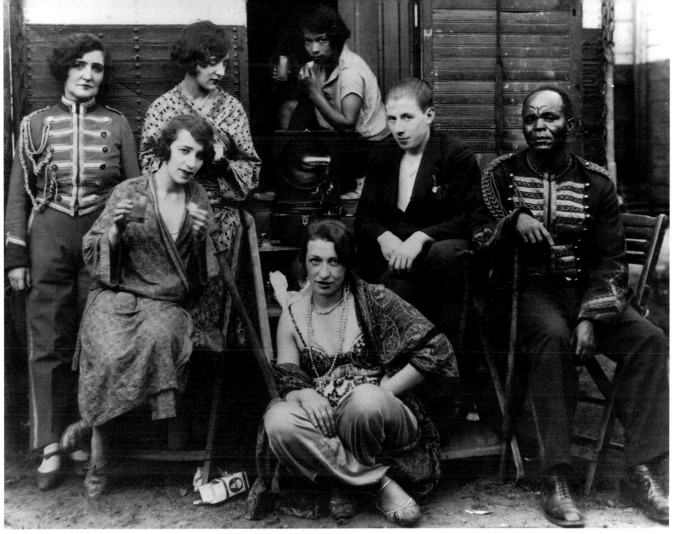

*August Sander spent years photographing his German countrymen in all stations of life. His direct and objective manner with the camera helped to establish a new genre that would later be called documentary.*

August Sander, "Circus People," c. 1930, © The estate of August Sander, courtesy of Sander Gallery, New York

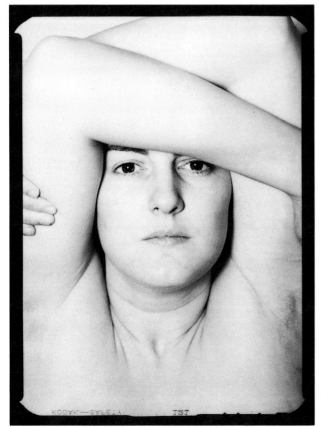

*Harry Callahan mixes design and human interest in these portraits of his wife Eleanor. His execution of both versions ably demonstrates that literal translation is not mandatory.*

Harry Callahan, "Eleanor," courtesy: Pace/MacGill, New York

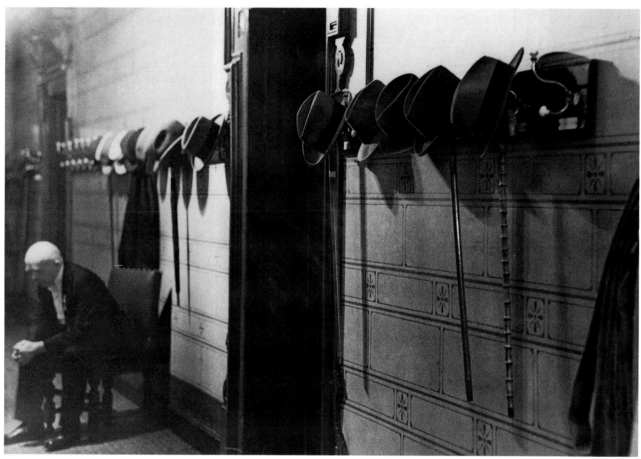

## CANDID PHOTOGRAPHY

Perhaps the greatest appeal of candid photography is an emotional one. It is the opportunity to study closely a person captured in time without risking embarrassment. It is almost a forbidden fruit, the eating of which requires no penance. There is no rush of the hurried glance, no need to conceal our interest. The plain fact is that people are interested in other people—even the most egocentric of us. In many primitive cultures, staring at someone is not considered rude—it may even be a compliment.

Candid photography is as old as the arrival of relatively fast emulsions and lenses. There was little chance of a candid photograph when it took 20 seconds to expose a plate. But soon, photographers with more portable, less obtrusive, and more sensitive equipment began to find the hidden joy of photographing people who were not affected by the presence of a camera. Most people react to the camera as they react to a mirror or to meeting a stranger. Their self-consciousness becomes a mask that covers the real personality.

The beauty of candid photography, then, is twofold. The subject of a candid photograph is allowed to remain in a natural state, unknowingly offering the real self to the camera. The viewer, too, is freed from the self-consciousness of scrutinizing a stranger face-to-face. He can spend time analyzing the subject of the photograph. Both parties are saved the trouble of their own embarrassment.

The sensitive photographer, of course, will not invade another's pri-

*Before highly sensitive films and multi-coated lenses, Erich Salomon fascinated newspaper and magazine readers with his candid photos of statesmen and politicians at work. Concealed behind drapery or mixing easily with the crowd, his instinct discovered positions of advantage and critical moments when there was sufficient stillness to permit his typical 1/4-second exposure. The realistic appearance of his subjects was no performance—they were photographed in action, completely unaware of Salomon's camera.*

Erich Salomon, "Outside the Conference Room," Ullstein Bilderdienst, Berlin

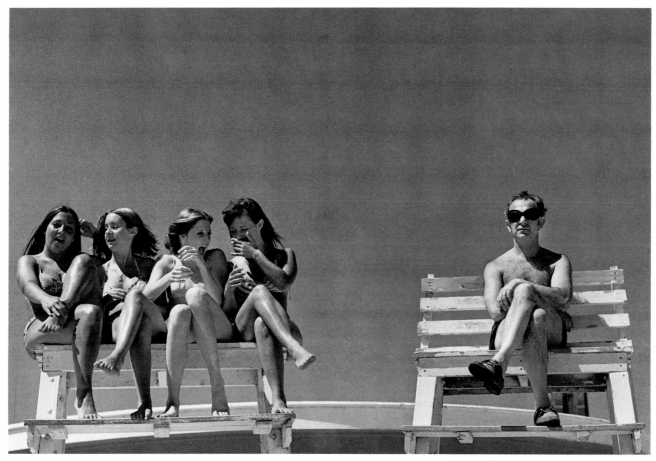

*Joseph Szabo studied adolescents for his book,* Almost Grown. *Szabo is accepted, then ignored by the young people he photographs. Unlike Salomon, he is a visible part of the scene, not a secret, yet his photos still capture the tumultuous spontaneity of his subjects.*

Joseph Szabo, "Lifeguard's Dream," from *Almost Grown,* © 1978

vacy in the crude tradition of the paparazzi, which may be how the word candid came to have a black eye (as well as many paparazzi). Spying is not the same as candid photography. The candid photographer is unobtrusive and compassionate. He is disposed to empathize with humanity. He is not inclined to expose what people are trying to hide, but to reveal their character in a warm, heartfelt manner. The candid photographer is basically an optimist who likes his subjects.

Black-and-white photography seems to force immediate attention on a candid subject. It is as though the medium itself extends the emotional contrast range. Peripheral material in the frame becomes unnoticeable, and the subject seems to leap out of the print. And because the materials and techniques may often be somewhat different from landscape or portrait photography, the candid print has a unique appearance.

Photographers may use long lenses to keep out of the subject's field of awareness or short lenses to become part of the action. Fast films are the norm for tricky lighting and moving subjects, and for handholding telephoto lenses. Faster films mean grainier enlargements and perhaps lower contrast with softer edges. These changes from the so-called norm of the fine print do not in any way diminish the impact of such a photograph. Indeed, the almost reportorial appearance may well enhance the overall effect.

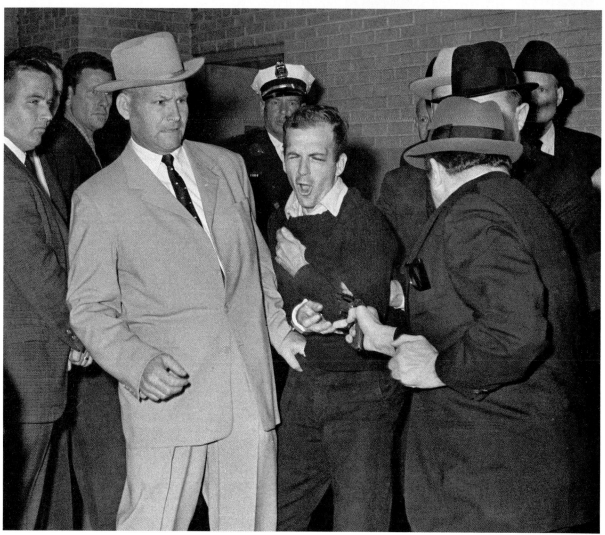

Bob Jackson, "The Shooting of Lee Harvey Oswald,"
© Bob Jackson, Dallas Times Herald

## PHOTOJOURNALISM

Photojournalism—the mere word creates a vision of lean, keen-eyed, intrepid people willing to take any risk to get the storytelling picture. It brings to mind the drama of some of the best-known scenes of all time, displayed dramatically across the front pages of newspapers. But the whole truth is a bit quieter. Most photojournalism is produced by hardworking individuals who are sensitive to, and knowledgeable about their subjects. The typical subject and resulting photo may not be dramatic. The successful photo is complementary to the narrative at least, eye-catching (and paper selling) at best.

Journalism is basically a trade of events. The stated purpose of a newspaper or magazine is to give the news—daily or weekly. Pictures give the text extra dimension. Or, conversely, words define the activity or subject of a photo. And, in most cases, the words and photos describe events—one-time occurrences. The importance of events to the reader is judged by the impact they make on humanity. The photograph shows how an event touches the lives of the people involved. Wars, natural disasters, political rallies, accidents, even portraits of community, national, or international leaders are interesting because of the way people are affected—at the moment and perhaps ultimately—by the event portrayed. The drama of a news photograph depends on the emotional impact it makes on the viewer. The photograph forces empathy because it shows people similar to himself exulting, suffering, reacting, and responding.

We take news photographs for granted, but at the turn of the century it was comparatively new and a rather suspect and limited practice. Although the halftone dot method for duplicating a photograph's tones on a printing press had been known for some time, tradition was still on the side of the artists and engravers who supplied illustrations for the news media of the day.

With the acceptance of halftone reproduction came the first practical method of reproducing photographs for print. Farsighted and ambitious newspaper publishers overrode or ignored the criticism that usually accompanies any daring innovation and quickly established the photograph as an integral part of the newspaper—one that definitely contributed to newsstand sales.

In the early years photographs were frequently used to shock and titillate. As a more professional and moderate ethic improved the gathering of news, so came an uplifted standard for the news photo. Treatment of the subject and the subjects themselves became more newsworthy and photojournalism became an integral part of the newsgathering process. In-

Charles Corte, "Helen Keller Sees the President," permission courtesy UPI/Bettmann Archive, permission; copy negative courtesy Mr. John Faber

deed, it is impossible to imagine any newspaper without pictures that extend and amplify, describe and explain the event under examination. It is important to remember that many of the best-known photos of all time were taken for news publication.

Successful photojournalism consists of many elements. First, the photographer has to be on the scene, equipped and prepared to make the shot. He or she must have the necessary technical qualifications to make correctly exposed, sharp images under the very worst conditions. The photographer must also have the eye to find the right position and to compose a picture that not only tells the story but catches the drama of the event and ultimately the reader's eye. The final but equally important element is the sixth sense (often defined as luck) that enables the photographer to capture the climax or unusual twist of the event.

Much photojournalism is performed with monochrome materials. The reason is simple—color is expensive to print in newspapers and magazines. Black-and-white can be processed and printed quickly without elaborate setup in difficult situations. The exposure latitude of black-and-white film far exceeds that of color transparency film (favored for color lithographic reproduction) so that even a terrified photographer exposing his last frame in the face of imminent annihilation can expect to make a negative that will produce an acceptable print.

When news photos are produced under hurried and even dangerous conditions, the print used for publication is often of less than ideal quality. But because of the nature of the subject, technical quality (or the lack thereof) rarely interferes with the message or the impact. The combined effects of high-speed films, barely ad-

equate existing light, enlargements of small areas of the negative, hasty processing and printing techniques (not to mention wire service transmission and reproduction with coarse screens on newsprint) should be devastating to news photos. But instead, they serve to convey the urgency and pain of a riot, a flood, or a car accident. Or they may augment the intense personal interaction, the wheeling and dealing of a political convention.

Journalistic photography apparently has power to influence as well as the ability to communicate. Several photo artists have developed techniques that parallel those of the news photographer. André Kertész, Henri Cartier-Besson, Robert Frank, Danny Lyons, Gary Winogrand and others have a style that treats a wide variety of subjects, but mostly people and their doings, in a way consistent with photojournalism.

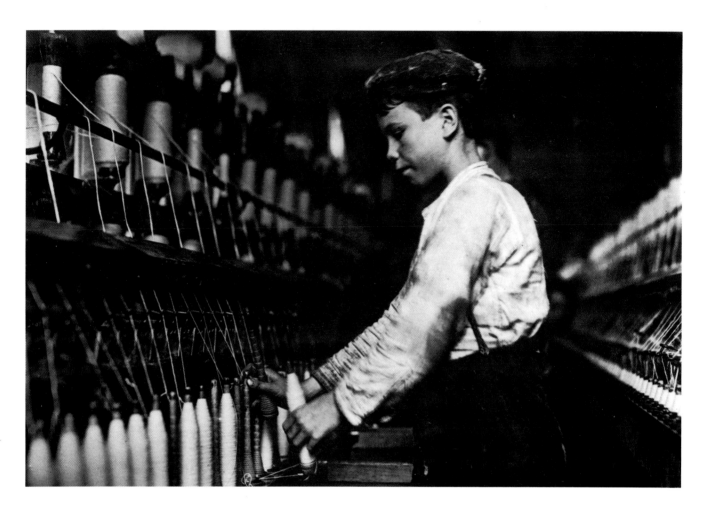

## DOCUMENTARY PHOTOGRAPHY

If photojournalism is the study of events, then documentary photography should logically follow as the study of conditions. Beginning with Englishmen John Thomson and Peter Henry Emerson, the camera took an appraising view of people and the surroundings. Although neither man could be considered a social critic, the photographers that soon followed pursued similar subjects with a definite purpose—to expose and improve the lives of those less fortunate.

When Jacob Riis found that editors ignored his words describing the deplorable conditions of slum dwellers and immigrants in New York City, he embraced camera work. His pictures were irrefutable, opening a new era in social endeavor. Louis Hines, among

other projects, spent years exposing practices of child labor with his camera like a latter-day Dickens. The power of his photos led to modern child labor laws.

Although social documentary is one branch, less dramatic areas of inquiry help complete the tree. Like the news photograph, the documentary photograph or series of photographs needs an audience. Until the widespread use of halftone reproductions, it was impossible to communicate to a wide audience, but with inexpensive and practical reproduction on the printed page came pictures of far-off lands.

In the first decade of the 20th century, the *National Geographic* magazine experimented with photographs

to heighten the impact of its wide-ranging subjects. The response was immediate and popular. The magazine continues with its 80-year scientific and geographical program of informing through photos. Essays in other popular magazines helped readers (or are they viewers?) join people in all parts of the world. Whether it was villagers in Spain, college football, a day (or week, or month) in the life of a person interesting or ordinary, the photo essay put people in touch with other people.

Some of the best-known American photo essayists got a start with the New Deal in the Farm Security Administration (FSA) under Roy Stryker. Assigned to document Americana and its suitability as a

(Left) Lewis Wickes Hines, "Child Labor — Cotton Mills," International Museum of Photography

(Right) Walker Evans, "Burrough's Kitchen," Hale County, Alabama, 1936, Library of Congress

habitat during the Depression years, these photographers roamed the land in search of people and their surroundings. Times were hard and the photos reflect those conditions in the faces and backgrounds discovered from coast to coast.

Although most large circulation, general interest magazines have ceased to exist, the photo essay is alive and well in countless special-interest magazines. In taking the sum total of all these publications, the same rich variety of subject and approach is still available as when *Life, Look, The Saturday Evening Post*, and *Collier's* were in their heyday.

Because the nature of the assignment is usually different from that of the photojournalist, the documentarian is granted time — time to carefully research the topic, time to consider an appropriate photographic approach, and time to test the results. In any case, the situation is far removed from the one exposure-and-crossed-fingers of the newsbeat specialist.

The extra time allows opportunity to perfect the image, starting with the ability to shoot from a variety of viewpoints, try a smorgasboard of equipment, process film with care in a professional laboratory when available, and make prints that would stand up to fine screen, slick page, enlarged magazine or book reproduc-

tion. Since the subject is viewed over a period of time, the sense of immediacy and timeliness is lost. The higher quality print helps to diminish the feeling of urgency. The improved image quality lends itself to a more detailed study of all the elements of the photograph, rather than one or two main subjects.

Documentary photograpy is a distinct medium aimed at a slightly different audience. Alone or in grouped essays, it is widely recognized as a unique photographic phenomenon. Through the decades, many of these remarkable images have become a strongly imprinted part of our visual heritage.

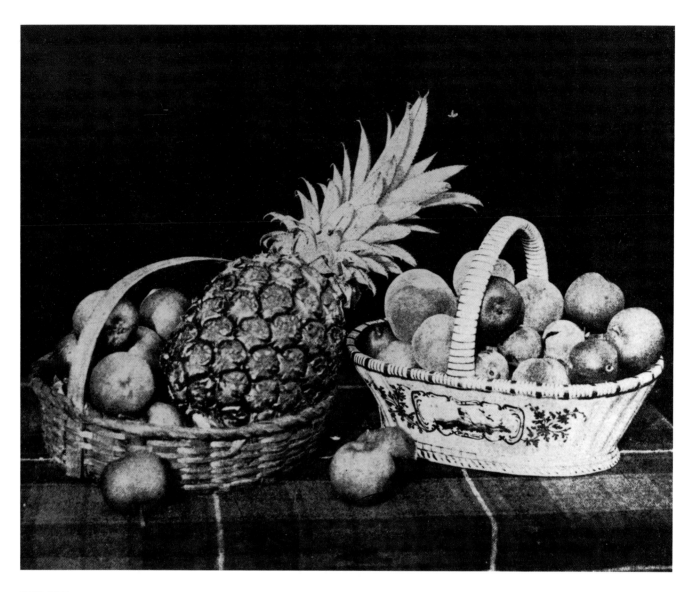

## STILL LIFE

Of all pictorial genres, the still life may be the most familiar. It is and has been a favorite subject since man began to explore his secular surroundings during the Renaissance. And from that fateful moment when Niépce dipped his fingers into asphalt, the still life has been a staple of photography. Moreover, in almost every facet of 20th-century communication, the still-life illustration serves to inform or entice.

Three reasons for still-life popularity in photography come immediately to mind. First, the subjects don't move, which highly endeared them to early practitioners of the camera art. Long exposures rolled easily off the backs of fruits, tableware, small statuary, and other chattel common to the 19th-century household. (Although fish appear frequently in paintings of the period, we can assume that dead fish did not easily tolerate long exposures and high temperatures.) Next, the lighting was easy to control with windows, skylights, and reflectors. Lastly, the still life had long been a theme for painting and it transferred naturally to the newborn, self-con-

scious medium of photography.

Why has the still life remained popular, even after generations of faster films, faster lenses, and convenient, portable equipment made spontaneous location shooting a comparatively simple task? The answer lies in the subjects themselves.

Photographers are visual creatures who respond to what they see. Arranging a collection of the utensils we use blindly and the morsels we eat without a second thought becomes an exploration of the environment. Studying the minute details of such

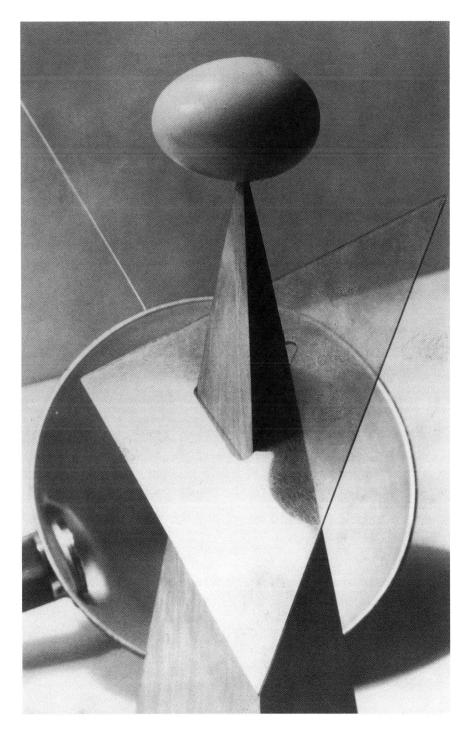

*This delightful still life appeared in Talbot's book,* The Pencil of Nature, *which contained original Calotypes, the first photographically illustrated book in the world. With the publication of this book, Talbot hoped to popularize the Calotype process against the unreproducible daguerreotype process. Still life scenes provided ample opportunity for early photographers to experiment with light and composition.*

W. H. Fox Talbot, "A Fruit Piece," 1844, Calotype

*Compared to the photograph at left, Outerbridge's assemblage seems radically modern. In fact, there is nothing especially new in the items themselves— it is the seemingly whimsical arrangement that stops the eye. This still life, however unusual in appearance, fulfilled the mission of all still life images—it provided the artist with a necessary challenge in lighting and design.*

Paul Outerbridge, "Triumph of the Egg," 1932, courtesy: G. Ray Hawkins Gallery, Los Angeles

subjects allows the photographer to fully experience his surroundings. It forces on the audience the obligation of committing to visual consciousness objects which previously belonged to our world through utilitarian function or through another sense such as feel, taste, or smell. The still-life photograph is a glorifcation of existence—a raising of the mundane to a position of value. (Naturally, an advertising still life that features an $85,000 diamond necklace is anything but a celebration of mundanity—it is security for the photographer.)

A photographic still life is not only a celebration of the subject—it is a statement about the medium itself. Because the photographer can manipulate all aspects of the monochrome still life—lighting, camera handling, composition, and tonal reproduction—the still-life photograph is often a dramatic exercise in exploring detail, form, and chiaroscuro. It is one avenue by which the photographer can push his craft to the very limits.

Still-life subjects appeal to photographers because they tease from their obscurity, provoking a challenge to be portrayed as worthy pieces of experience. And on closer observation, they may wear an intriguing visual habit that forces a photographer to pull out all the stops to convey his impressions. The audience is similarly rewarded. The little-noticed objects of daily life are given importance by scrutiny from the camera, thus enriching one's own visual experience. Those who appreciate fine photography will be gratified by recognizing the power and craft required by the simple still life.

## EXPERIMENTAL/AVANT GARDE

Many artists working in black-and-white have toiled in a variety of photographic contexts, many of which have already been explored, such as landscape, portrait, candid, and so on. One area that defies simple definition is work that challenges the outer edge of the known and accepted photographic medium.

With any branch of the arts it is often difficult to find the radical elements of a movement that occurred 50 years earlier. Work with merit, no matter how outrageous at the time, tends to endure. Van Gogh's painting was considered the scribbling of a madman—which hardly seems to affect the price of his paintings at today's auction. People resist change. Preconception and familiarity are two of the cornerstones of taste. With time, what's new and vulgar becomes commonplace and tolerated. With more time it may become venerated as a cultural totem. What is ridiculed today may well be the masterpiece of tomorrow. When we speak of the radical experimentalist of 50 years ago, we speak relatively. That person's work may well be a cherished part of our fine-arts heritage. Nevertheless, some artists constantly challenge the norm both with work and life, and these people we often remember as flag bearers of the fine-arts van.

Because photography is a comparatively young medium (with only 150 years of accomplishment), it is easy to discern movements and prime movers, some of whose work, even out of context, appears unusual and even shocking today. In many cases, photographers were able to break with their brief tradition because of changes and advances in the medium. In other circumstances, changes in the environment (political and social) brought forth a swing in the attitudes of photography.

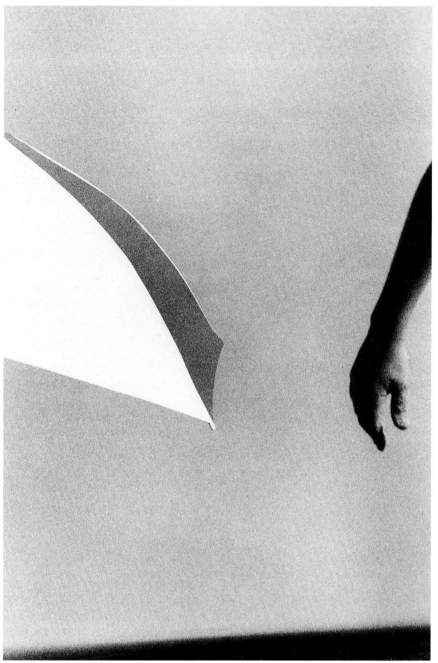

*This striking viewpoint with drastic cropping gave a new perspective on summer beach scenes.*

Ralph Gibson, "Hand and Umbrella"

Challenging the limits of the medium clearly inspired the work of Man Ray. Breaking the technical rules was the byword of his art. His delight in jousting with photography's taboos is evident in the fresh spontaneity of his still-startling images. Defying current thought by returning to a day before the camera could stop action, Duane Michaels provides images of transcience and impermanence with his blurred images in famous sequences. His imposed disregard for the boundries of photographic properties and artistic guidelines have forced a new awareness of media freedom within related visual disciplines.

On the other hand, advances in photo science have often provided the agar to support original ideas and bold, new techniques. The slice-of-life images by André Kertész and Henri Cartier-Bresson became possible only with the advent of the small handheld 35 mm camera.

New approaches to the subject are the result of independent thought. Clearly, the striking portraits of Hill and Adamson, Julia Margaret Cameron, Lewis Carroll, and later Steichen, Käsebier, Brandt, Avedon, Diane Arbus, and others show the individual artist's drive to express character with little regard for convention. Weston's still lifes and Minor White's landscapes show the artist's intense desire to discover or create a new order for the universe. Portrayals of suburban living through the eyes of Gary Winogrand or Lee Friedlander open up an extended range of "acceptable" subject matter. Aaron Siskind discovers feeling of form and relationships beyond the definition or the appearance of the subject. And at this date in the late 20th century, some artists are striving to portray modern subjects with antique photographic techniques that alter temporal relationships and provide scrambled context.

It is often deemed inappropriate to mix commercial enterprise with art performed for art's sake. Nothing could be more narrow or provincial. Some of the most treasured "Old Masters" are themselves commercial, produced for a client with cash. The case lends itself to photography as well. Often the most brilliant minds behind the camera found the need to support their flesh with advertising and commercial work. The genius of people like Edward Steichen, Eugene Smith, Richard Avedon, and Gordon Parks was often applied to making striking advertisements or documentary essays.

Naturally, the history of monochrome photography is longer than that of color, so there's a longer continuum to search for experimentation. Certainly color itself has proved useful for exploration. But the distinct properties of the black-and-white image have lent themselves to

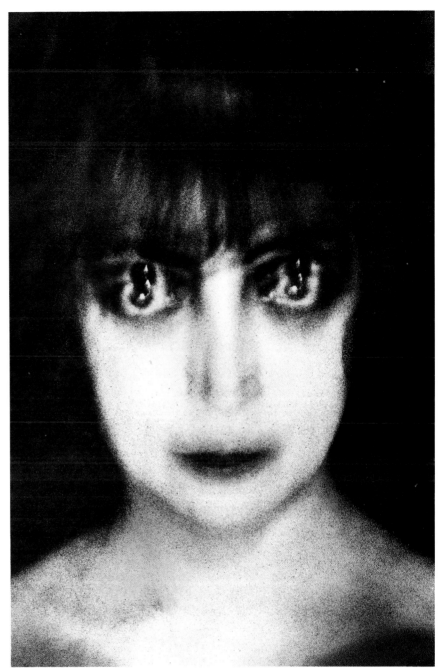

*The doubled eyes add kinetic vitality to a beautiful visage.*

May Ray, "La Marquise Casati," c. 1930, courtesy Juliet Man Ray

challenging the norm. Perhaps it is possible to say that there are more interesting "mistakes" to be made with monochrome. A mistake in one era can be the hallmark of the next.

Altering the appearance of a normal scene is easy, and the vast array of means for altering black-and-white photographs offers itself to the photographer willing to risk breaking the rules. Exposure and contrast are the two main variables. There is an incredible number of processes, new and antique, available for different interpretations of the subject. Manipulative camera work is also possible

and although not unique to black and white, certainly can convert an ordinary scene to an expressive photo. The range of means for expressing a private view of the world is nearly inexhaustible—from the filmy, diffuse portraits of Gertrude Käsebeir to the harsh, crisp images of Paul Strand, there is a universe of variable photographic interpretations. Whatever the statement, there is very likely a suitable monochrome portrayal that fits the artist's needs. The only requisite is an intelligent choice of tools and the courage to throw convention out the window.

# Characteristics of the B/W Image

According to the tradition of Western culture, there is a portion of merit in each person. Certainly, it is smaller and more difficult to find in some individuals than in others. The same gentle axiom can be applied to artistic media. It can be extended to say that each medium has unique advantages and corresponding disadvantages. Monochrome photography combines an impressive array of strengths and a surprising lack of weaknesses. Its main strength is its weakness—rather a half-full, half-empty situation—it doesn't show color. But since there is another photographic medium that does show color, nothing is lost.

Black-and-white is a designer's tool, a sensualist's caress. Denying the apparent reality of color, it begins as an abstract representation. And because abstraction is a cornerstone, the artist is not obligated to any prearranged standards of representation.

The technology of monochrome photography allows considerable variation in means of representation and, added to the options in camera work, there are few limitations that would separate an artist's ideas from the final product. The following pages display and describe some of the attributes important to black-and-white image making, including designing with dark and light tones (chiaroscuro), sensitivity to patterns and texture, tonal range (contrast), tonal area (key), and compositional elements which will heighten the impact of your statement.

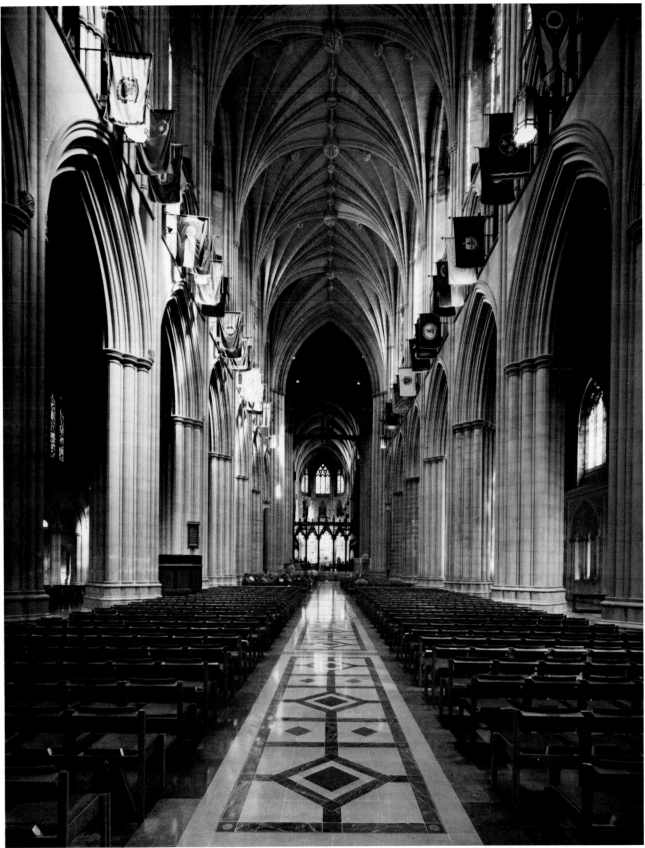

Norm Kerr

*When detail, ornate and exquisite, overwhelms you at the scene, be sure to use a film that is fine grained enough to overwhelm viewers of your print. The photographer used KODAK T-MAX 400 Professional Film to photograph the National Cathedral because of its extremely fine grain and high resolving power.*

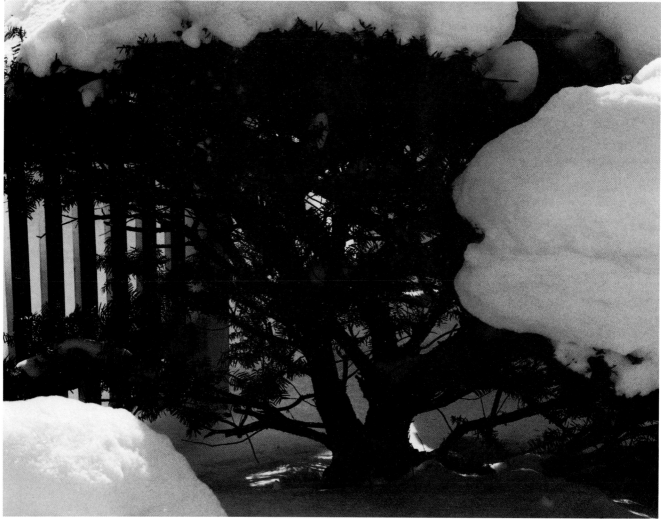

Martin L. Taylor

*The interweaving of lights and darks with a balance of large tonal masses against feathery conifer needles creates a delicately poised image of winter.*

## CHIAROSCURO—DESIGNING WITH LIGHTS AND DARKS

The word chiaroscuro is derived from Italian roots—"chiaro," meaning clear or light and "oscuro," meaning obscure or dark. It has two dictionary meanings: 1. A pictorial representation in terms of light and shade without regard for color, and 2. The arrangement of light and dark parts in a pictorial work of art.

The word could have been coined for monochrome photography, which itself is pictorial representation in terms of light and dark without regard for color. This brief discussion concerns itself with the idea of arranging pictorial elements with regard to their lightness or darkness.

Monochrome photographs may have an infinite variety of tones or merely a few—in a broad range or in a narrow one. But within the boundaries of the picture frame there is bound to be some interaction of lighter tones and darker ones. This interaction provides balance or imbalance, tenseness or tranquillity, drama or mystery, logic or calculated insanity. A preponderance of one end of the scale over the other may flavor the mood of the picture. How the ends of the scale are arranged helps to point the viewer toward an understanding of the photographer's statement.

For many photographers, framing the scene automatically takes chiaroscuro into account. Knowing how film and paper, react to exposure and processing enables the artist to visualize the scene in the viewfinder, subconsciously juggling the areas of light and dark for the desired effect. But it may be profitable when composing a scene to stop and consider what the effect will be. Colors do not translate easily into tones of black and white. Some elements of the scene may become lighter or darker than intended. Exposure, processing, printing, and camera filtration all help to achieve the desired result. Forecasting how the scene will appear in gray tones should help to tighten the composition and heighten the impact.

36

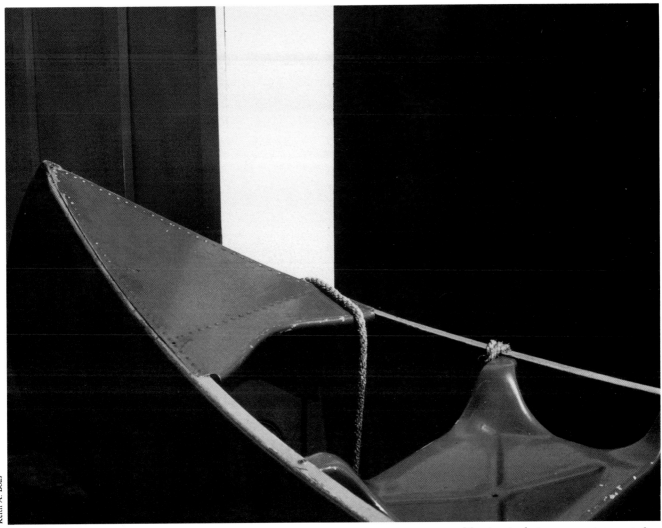

Keith A. Boas

*Massive single-tone areas, interrupted with only a hint of texture, convey the feeling of oppressive, inescapable light— the weight of summer.*

At first glance, a symmetrical arrangement of light and dark subjects that provides an even balance from side to side and from top to bottom would seem to promote feelings of calmness and order. Perhaps the opposite is true. The rigid order of the photograph, often lacking in nature, may cry for the intervention of an additional element, giving a tense expectation of something about to happen. On the other hand, a scene casually arranged, seemingly out of balance, may impart a sensation of suspended time as though one walking foot has hesitated in midair, waiting only to fall and for the other foot to rise. Often, however, this act of pictorial suspension provides a dynamic balance comparable to that of a gyroscope, far more stable in motion than a dead weight at rest.

Massing dark areas against a similar weight of light areas may give an impression of solidity or inertia, whereas fragmenting and interspersing dark areas with light areas should create an aura of weightlessness and feather delicacy with movement implicit in those properties.

Contrast and key (usually controlled by the photographer) help govern composition. A contrasty print may very well use a simple arrangement for added power, while a complex image with smooth gradation of tones will lend itself to more subtle style. Extremely high- or low-key representation should be adaptable to simple arrangements, while intermediate long-range scenes will permit complexity.

It is worth repeating, however, that chiaroscuro is only one consideration in picture design. It must function with knowledge of the other elements that will make up the final print. All facets of the print work together to produce the intended effect upon a viewer.

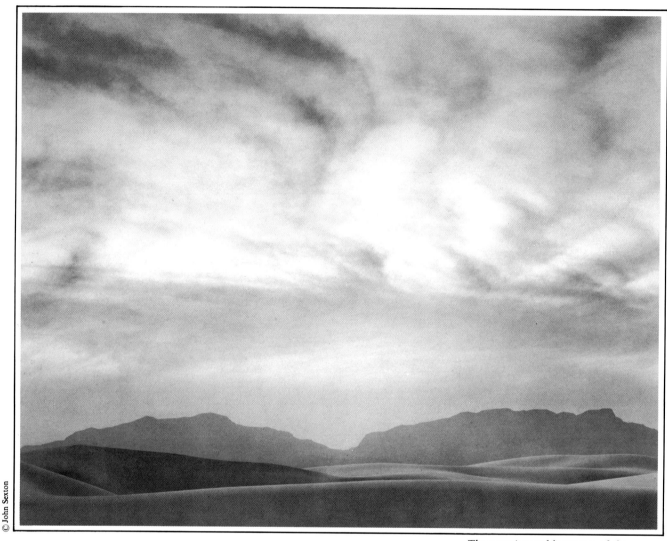

© John Sexton

*The serenity and harmony of this landscape is carried by the bright and medium tones, and the lack of a contrasting deep black.*

## CONTRAST

Contrast, or the lack of it, is inevitable in black-and-white photography. Color photography has little provision for the control of contrast, but black-and-white materials offer a wide range of tolerance which in turn gives immense contrast control. It is one of the foremost variables in the medium and one that has a great influence on the emotional impact of the print.

High contrast, low contrast, and all of the moderate stages in between allow the photographer to evoke a mood or provoke a sensation. In determining how to record a scene, the photographer must consider contrast and its considerable influence on his statement. For instance, what is the contrast (brightness range) of the scene? Will the scene be more appropriately portrayed as high contrast, low contrast, or somewhere in between, in the so-called "normal range?" How should it be modified— camera technique, darkroom procedure, or both?

High-contrast prints may relate a sensation of activity, intensity, and expectancy by strictly confining the viewer's attention to critical scene elements. Nonessential details are elimi-

38

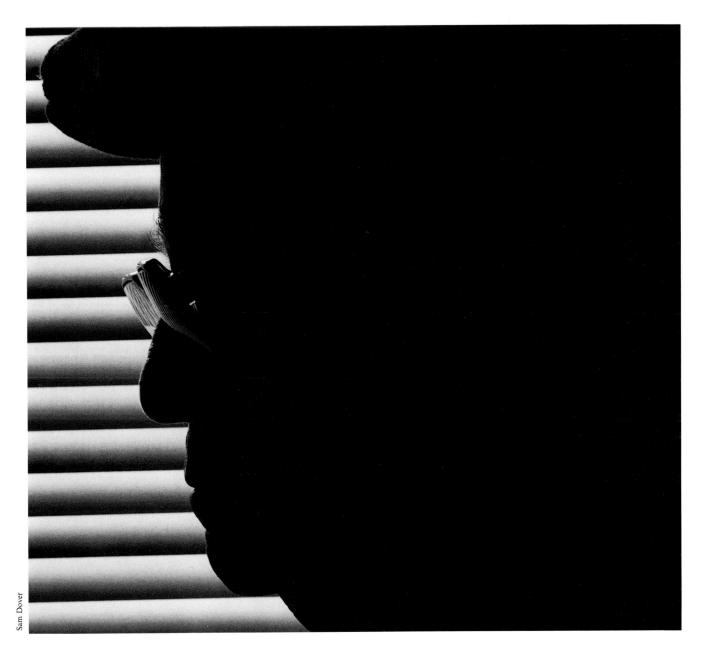

Sam Dover

*The bold contrasts of this picture are twofold. First is the stark tonal contrast of an image made almost solely with black-and-white tones. Second is the reduction of a scene to the two basic elements of line and shape, which then dominate the picture.*

nated by deep shadows or glaring highlights. It is also possible to find a somber representation of a subject affected with high contrast. Low-contrast images often place feelings at the other end of the spectrum. A closely grouped narrow range of tones can impart a calm, moody, static atmosphere by presenting all information—important and trivial—on a more-or-less equal basis. An apparently normal or moderate range of tones offers the involved spectator's viewpoint—where technique is carefully subordinated to the subject so that the print strictly represents the actual scene.

Both high-and-low contrast portrayals can become technique-heavy, where the technique is observed first, followed by recognition of the artist's intent. (Naturally, this isn't the case for a subject which is particularly appropriate for contrast manipulation.) Generalizations are dangerous, but successful prints usually involve the viewer with the content, leaving the technique an afterthought. Contrast—in the scene, in the process, and in the final print—is treated as a control available to you in the section beginning on page 48.

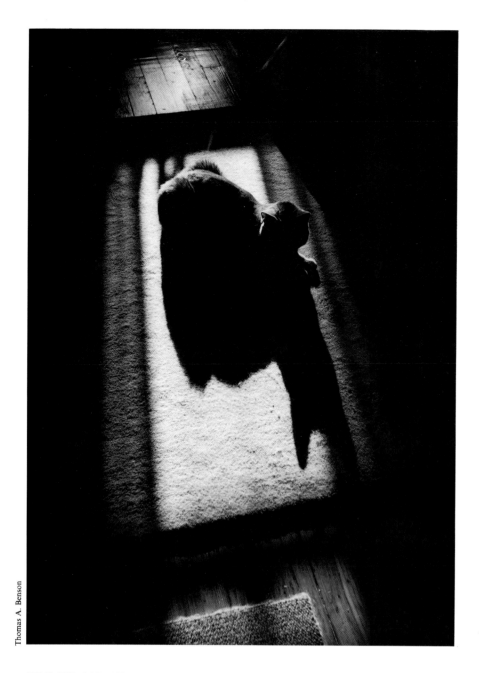

Thomas A. Benson

*The low-key image at left projects a somber atmosphere, entirely in keeping with the subject. The highlight area provides believability and impact.*

## HIGH KEY, LOW KEY

Key refers to the overall tonal appearance of a print. In a high-key image light tones predominate. In a low-key image dark tones predominate. When a print can be described as high- or low-key, the subject is usually the source of the tonal flavor. When a photographer notices a preponderance of tones toward one end of the scale, he may want to amplify the effect.

Photographs with tones grouped high or low have a direct influence on the overall mood of the image. Because this aspect often creates the first impression, the key may aim the direction of a viewer's reaction. Later impressions from the subject and perhaps further manipulation may bolster or contradict the first impression, depending on the intent of the photographer. High-key images tend to broadcast an ethereal, cheerful, weightless atmosphere. Low-key photos, dark and often gloomy, speak of the reverse—earthbound melancholia. First impressions may agree or disagree with the content of the photo, but the latter requires skillful manipulation, some humor, and a desire to surprise and shock.

The logical assumption that high- or low-key photos would be low in contrast is quite false. Such images

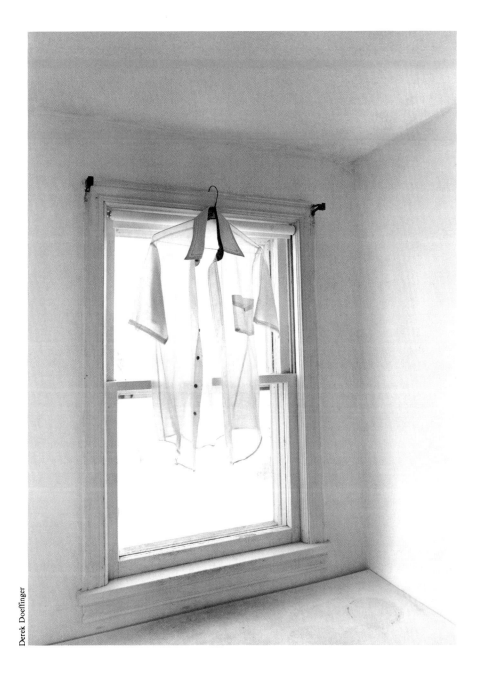

Derek Doeflinger

*The whiteness of the room contributes to the filmy, transparent quality of the shirt hanging in the window. It would appear unreal except for the shadowed collar and dark-metal curtain rod hangers.*

frequently have far more impact when the overall tonal pattern is interrupted by the exception—a contradictory area included to prove that the rest of the image is intentional. In a high-key image, a dark shadow or subject helps to establish credibility. In a low-key photograph a reflection or a shaft of light—perhaps a sliver of white fabric—improves the viewer's ability to relate the unusual scene to his own sense of reality. Not that reality is the aim of high- or low-key photography. Far from it. The exception is a small gesture of defiance from the other end of the tonal scale that usually gives additional striking

force to the image.

Although the scene usually determines the key of the photograph, the photographer can manipulate his exposure, processing, and most importantly his print-easel work to augment the impression given by his subject. Generally it means lowering the contrast when making the negative and then carefully printing-in or dodging the small areas of exception. Overall, the print will have low contrast. The areas that contradict this impression must be given special attention under the enlarger light.

Bruce Barnbaum

*Rich in line, shape, form, and, texture, this photograph shows how powerfully a photograph can depict reality.*

### LINE, SHAPE, FORM, AND TEXTURE

It seems like an afterthought to address the familiar aspects of picture design. But having described some of the unique features of monochrome photography, it might be helpful to tie them into a brief discussion of more common image-making concepts, such as line, shape, texture, form, and patterns.

Lines define and separate. They help determine distance and establish relationships. In black-and-white photography they may be black, white, or gray. Lines may be sharp and contrasty or they may be diffuse and subtle. The structure of a photograph often includes lines—straight or curved—that tie elements of the picture together.

The shape has a line for perimeter and is often filled in. Shapes are im-portant because we recognize a universe of subjects by shape alone. A shape can be massive, ephemeral, large or small, dark or light. A recognizable shape can provide the comfort of familiarity. A strange shape can create mystery and tension. Intense dark or light shapes may be more dramatic than shapes in middle tones. A collection of many shapes appears busy and unsettled unless regimented into a pattern. One or two shapes, however, may seem calm and serene. The placement of shapes in the middle of the frame, near the edges, or in between can alter the impression given by the photo. Directly in the center, the shape subject draws all attention. Away to the side it seems to wait for something else to enter the scene. Silhouettes are shapes—brilliant highlights can be shapes. Middle-tone shapes with areas of highlight and shadow become forms—three dimensional rather than two dimensional.

Form is the name given to the impression of depth provided by transition from light to dark on a single object. The eye and mind know that when directional light strikes a three-dimensional object, all but simple geometric forms will show transitions from highlight to shadow. The more contrasty the rendition, the more abrupt the transition. The mind must contribute more information to perceive the subject as a form. When the journey is more gradual, textural detail is discernable over a broader range of shadow and highlight areas, which intensifies the impression of depth and mass. One of the key ele-

Norm Kerr

ments that helps create the impression of form is texture—a broken surface that extends the range of recognizable detail from highlight to deep shadow.

Texture is the word that describes the tactile impression of the surface. It is one of the signposts that photographers use to signify form. Texture can be rough or smooth. Included in a photograph, noticeable texture helps fool the senses into recognizing the depth and fullness of an object. Light-

ing creates texture—the irregular surface is broken up into minute areas of light and dark. High-contrast light can intensify a rough texture but kill the subtleties of a smooth texture. Conversely, the diffuse light of a less contrasty situation can bring out detail in a smoother texture.

Photographs use all of the above—lines, shapes, forms, and texture in varying degrees. The brain is programmed to perceive surroundings in

*From the fluting of the columns to the figures of the frieze, sidelighting etches out every line and texture as well as defines the overall form of the Supreme Court building. The exceptional sharpness and extremely fine grain of T-MAX 100 Professional Film caught and held even the minutest details.*

these terms. Using them in photography helps a viewer to unravel the photographer's message more quickly.

William A. Paris

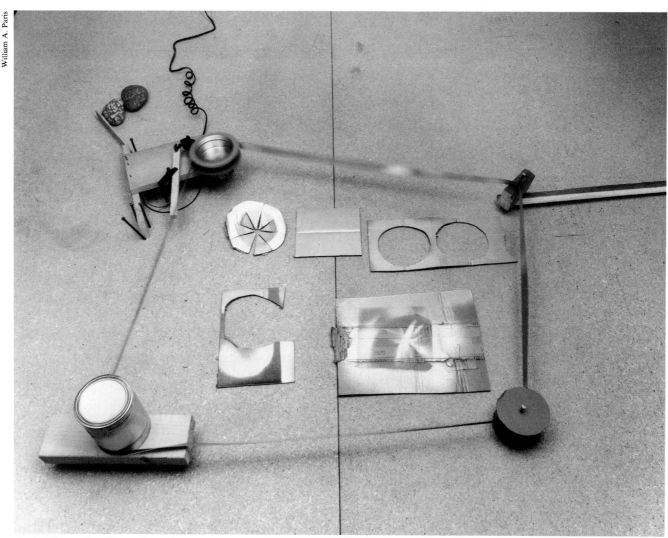

*In the illustration above, the artist created a kinetic construction, arranged it to his satisfaction, and photographed it. It appears that the image is a statement about photography, movement, time, and spatial relationships. Here, the print itself is the objet d' art—all else, including and especially the subject, has been subordinated to the photographic process.*

## ABSTRACTION AND INTERPRETATION

The elements given in this section—chiaroscuro, contrast, key, and structural components such as line, shape, form and texture—give the photographer a rich and versatile pallette for self-expression. These factors are largely controllable through camera work, exposure, processing, and printing. And with increased control, the photographer extends the range of his vision. His decisions create a unique image rather than a direct representation.

The subject is abstracted—first within the context of the medium, and then further through the photographer's desires and control. The image becomes an interpretation—a reflection of the photographer's state of mind rather than a mirror of the scene at hand. If the photographer chooses to mirror the scene, it is his wish to do so. If he departs from the scene, it is his need to discover an alternative or hidden reality.

The combination of all these tools is freedom—the ability to render a subject in a wide range of moods and from a wider range of psychological viewpoints. Black-and-white photography is definitely not a poor cousin to color. It is a discriminating tool for those who are visually sophisticated.

*Appearance versus reality. The humorous interplay of waves at the bottom with the looped, out-of-focus hose in the background creates a pleasurable sensation as well as a charming little mystery.*

Thomas A. Benson, "Garden Hose Through Sceen"

# How does a photograph speak?

*Analyzing the visual impression to be given by a photograph is a challenging task. At least three broad topics invite consideration. First, is the design of elements within the frame—the arrangement of subject and contributing subordinate subjects. Second, is the tonal treatment that helps to establish the mood or emotion of the scene. And finally come the mechanical (but no less critical) choices of print size, paper surface, base and image tone, and print presentation by mounting or matting, and even framing. The final display print arrives after a long sequence of interdependent decisions. It starts with seeing the subject.*

The first question that helps any photographer begin his decision-making process is the introspective search for why a scene appeals. When this is answered, the photographer is equipped to compose the scene in the viewfinder and make some judgements about how to expose and process the negative. When the photographer is firm about how he wants the image to appear (a direct outgrowth of how he felt about the scene in the first place), he can begin making the print. But here the process becomes complicated. New ideas will occur during printing and the original idea may evolve into a significantly different print.

Seeing a good contact sheet or the first working enlargement may trigger new thoughts about handling the information contained within the negative. After experimenting and arriving at the final print, the photographer must decide how to present it. This last step demands consideration of the intended audience and the display technique to be used.

Creative input for a fine print ends only when that print is on display or at least satisfies the photographer. It doesn't all happen when the shutter release is pressed. The preceding pages have touched on some of the aspects of seeing in black-and-white. The rest of the book is devoted to making photographs in the technical sense—converting visual impressions into monochrome images.

The following section offers a simple but effective method for making printable negatives, augmented by a good measure of printing advice. Then, a few words on print finishing should help to establish your ultimate image control. The last section provides some useful photographic options and sensible guidelines for presentation.

*Is the camera friend or foe? What's the photographer up to? Why'd he pick me? Spotted by the photographer in a grocery store in her "Sunday best," this girl soon found herself in a studio. Photographer Nick Vedros added only the gloves to her original outfit. The girl's wistful smile seems both knowing and dubious about the ways of adults. Vedros used T-MAX 100 Professional Film with a No. 1 diffusion filter to smooth the complexion.*

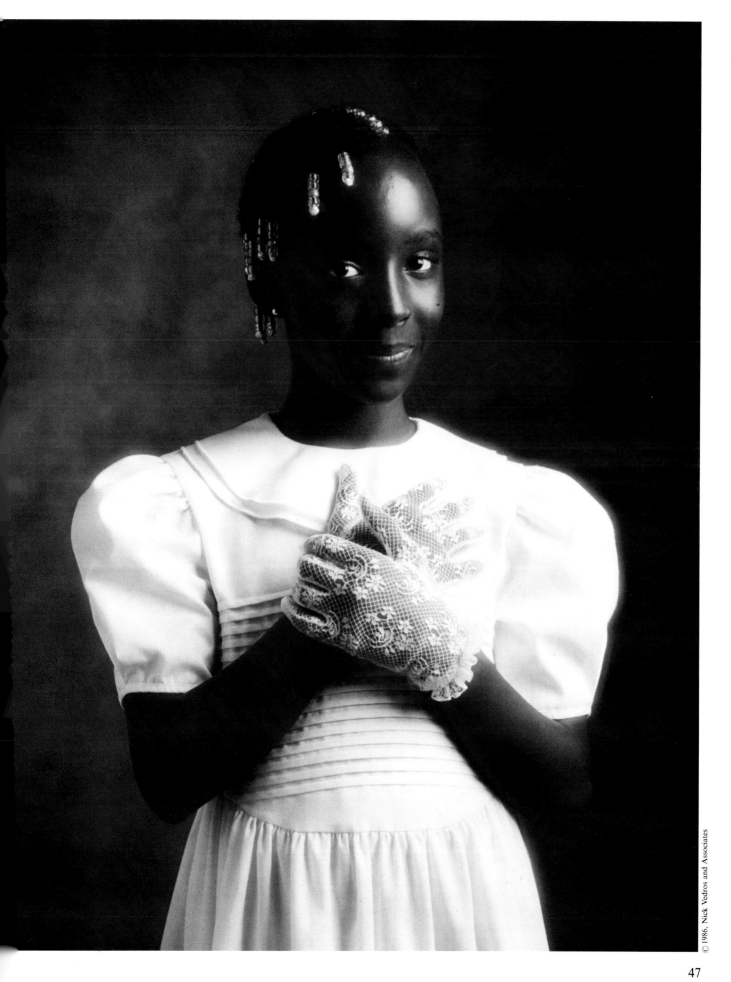

# Controlling your system

*Shutter speeds, apertures, lenses, scene contrast, meter, film, paper, temperature, film developer, paper developer, agitation, enlarger, photographer: These and many other factors are variables in your photographic system that affect the outcome of the negative and the print. By gaining control over these factors, you will be able to produce a high-quality negative and, subsequently, a high-quality print that reveals the scene as you envisioned it.*

The flexibility of black-and-white photography can be looked at in two ways. It can allow the sloppy worker wide margins for error and still yield workable results. Or, it can give the careful photographer freedom for a variety of controlled and intentional results. Although there is a margin of error within the tolerances of photographic hardware and software, you will find that you can account for most deviation through testing. (For instance, you may have a thermometer that consistently reads half a degree low. Testing will help you compensate for this error.) And the test results can be applied to later photography for consistent results.

It is not our intent to establish standards of acceptability. Excellence in photography cannot be provided by a formulaic, cookbook approach. The photographer must accept responsibility for those intuitive judgments that are not necessarily measurable, but are made in day-to-day practice and serve well toward the final result. Technique can only be appreciated as a flexible instrument whose purpose is to support and further photographic intention.

Our main concern in the following pages is to give you a practical procedure for testing and using conventional photographic software such as film, paper, and chemicals with your own system of photographic hardware, including your exposure meter, camera, and darkroom equipment. Our procedure operates on the assumption that the sophisticated photographer has the ability to observe critically and make choices that will gain desired results. The primary instrument for evaluation and judgment is your eye. To relate visual impressions to photography, you use a light meter, a fixed notation device that demands human judgment. But the basis of all photography is the human eye.

We want you to discover the methods that will provide you with an accurate and repeatable photographic procedure that allows you to expect and determine the outcome of the print by choice, not happenstance. The following pages offer a framework for discovering and applying measurable values to your photographic system. You are charged with providing the values through testing and experimentation. Once you feel comfortable with how the scheme works, you should begin to enjoy the sensation of confidence and the rewards of competence.

Owen Butler

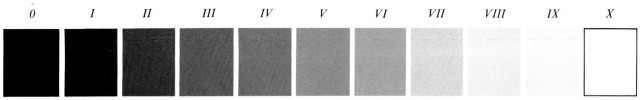

*Zone scale*

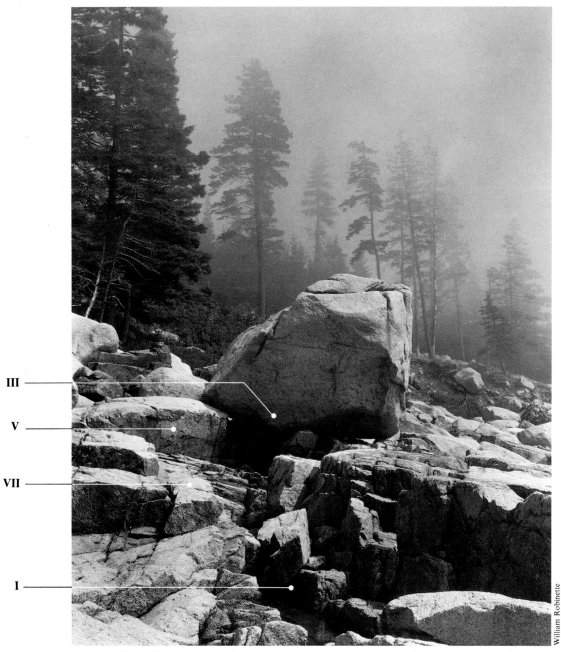

The scale at top shows the zones in the Zone System. In the photograph several of those zones are indicated. As shown by the scale, Zone 0 represents the darkest black possible by the enlarging paper; Zone X represents the whitest white of the paper. The Zone Scale is like a ruler marked only in inches, with no increments in between the markings. In the actual photograph, there is a continual gradation of tones between those marked on the scale.

## SYSTEM-SPEED NUMBER

Because it is the most important factor in establishing negative densities and hence print tonality, exposure of the film is a vital step in making a photograph. The film is exposed in an instant. The exposure is irrevocable. And during the exposure, there is no opportunity to select areas for increased or decreased density. Since exposure is so important, you have to make sure it's working correctly for your system. Exposure is usually based on the important shadow areas of a scene. It is then executed by the mechanical movements of the aperture and shutter as they open and close to admit light.

Four factors contributing to exposure immediately become apparent: the light meter, the aperture, the shutter, and the film. The more light (greater exposure) that reaches the film, the darker the negative will be. In short the darkness (technically, density) of the negative is an indication of the amount of light that reached the film. By measuring the density (darkness) of the negative you can determine if these four factors (and a few others) are working together to give correct exposure of the film.

If they aren't, you need only adjust the film-speed scale on the camera or handheld meter to compensate for them. **The goal of the exposure test is to provide you with a system-speed number to set on your film-speed dial that assures that your system is capable of capturing full detail in shadow areas (Zone III).** It's then up to you to meter the scene to determine the correct exposure (see p. 62-63). For those technically inclined, the system-speed number is the same as an exposure index. For those not technically inclined, the system speed number can be thought of as the film-speed number, except it is now customized to your system. You obtain this number by testing to find the exposure that adds 0.1 density (a light gray) above a blank (unexposed) negative.

The system-speed number may end up the same as the speed of the film you are using, although it is often somewhat lower. For example, if you do this test with KODAK T-MAX 100 Professional Film, EI 100, your results may indicate that you should not be setting your film-speed dial to 100. You may need to use a lower or higher number such as 80 or 160 to compensate for an off-speed shutter or an overly sensitive meter. The actual ISO speed of a film accounts only for the film, not for your equipment or the way you use it. The system-speed number accounts for your equipment as well as the film.

The exposure test assumes that getting enough light to give good shadow detail (texture) is important. The test adheres to the adage, "Expose for the shadows and develop for the highlights."

If you are familiar with the Zone System of Ansel Adams, this testing will seem familiar. A Zone System scale represents the full range of black-and-white tones, from the whitest white, through the grays, to the blackest black. The Zone System in this book uses eleven steps or zones. Some other systems use nine or ten, dropping off either or both extremes of the eleven-zone scale.

As shown on page 50, Zone 0 is the blackest black and Zone X is the whitest white. Each higher zone is twice as bright as the one before it. That means each zone in the original scene is equivalent to a one-stop exposure change from adjacent zones. For reference, the most significant zones are Zone III, Zone V, and Zone VII. Zone III stands for the darkest tone that should show significant detail (texture)—a shadow with detail. Zone V stands for the medium gray in the middle of the Zone System. It is the gray tone used by gray cards and the tone most camera meters are designed to expose for. Zone VII is the lightest gray that should show significant details—a highlight with detail (texture).

The Zone System gives a sort of yardstick of tones. By marking off the many gray tones in specific increments, it does what any standardized measuring system does: it allows you to standardize your thinking to be specific and accurate when adjusting your system for specific tones.

### ABOUT THE TESTS

To accurately judge test results **you should use a densitometer** to measure the density of the test negatives. Because it is an expensive tool, you might want to borrow or rent one. Custom photofinishers, professional photographers, graphic arts printers, photography schools, some dentists, and x-ray departments all might have densitometers. If you use one, try to verify its accuracy with a standard negative or step tablet that comes with the densitometer and is used to calibrate it.

Although we provide an alternative method of evaluation using the KODAK Projection Print Scale, this method is neither as accurate nor as reliable as using a densitometer. With the alternative method you find the test negative that matches the combined density (darkness) of the print projection scale overlayed on a blank negative. This method relies on your ability to visually compare different densities. If you can do this, then your evaluation will be fairly good.

Artistically, you should view these tests only as a way of fine-tuning print quality. If you were to make a before-and-after comparison of prints, the differences would normally be subtle, not so dramatic as the before's and after's of diet ads.

To some people, the tests that follow can be frustrating and time-consuming, especially if they lack the meticulous nature required for following procedures and keeping accurate notes. So if you decide to undertake the tests, do so with the foreknowledge that your ability to follow instructions may be tried and the afterthought that the final proof of success is the print, no matter whether it derived from thorough testing or prolonged trial and error.

## THE EXPOSURE TEST

The following test requires that you photograph a non-textured surface of uniform tonality. A solid-colored matte board would work. Choose one that is fairly dark and preferably of neutral color such as gray. You could also use a KODAK Gray Card. It is available from most photo dealers.

During the test you should use the same shutter speed for all exposures. You will vary exposure by adjusting the aperture. Since the shutter mechanism is more unreliable than the aperture diaphragm, maintaining a constant shutter setting during the test should give greater test accuracy.

1. Load your camera with the film you normally use, and set the manufacturer's recommended ISO film speed. Attach the camera lens you most often use. If you are using a film with ISO 125 or less, do this test outdoors on a cloudy day or in the shade. If you are using a high-speed film, such as KODAK T-MAX 400 Professional Film, perform this test in heavy shade (otherwise the shutter speed/aperture range may not be wide enough).

2. Position the gray card (or matte board) so it is **uniformly** lit and reflecting light without any glare.

3. If using a camera with a built-in meter, position the gray card so it fills the viewfinder area. If using a handheld meter, hold the meter no further than 18 inches from the card. In both cases, make sure you do not cast a partial shadow on the card.

*Photographing gray card*

4. Set the lens at infinity so the card is out of focus. This prevents any change in exposure caused by varying the lens extension and also produces a textureless image for a more reliable reading from the densitometer.

5. If using roll film, you may want to mark the beginning of the test, by sticking your hand in front of the camera and photographing it. Now put on the lens cap and shoot a blank frame. The second frame following your hand will be the first test exposure. If using sheet film, shoot one blank sheet as just described. Keep careful notes of the test exposures which follow.

6. If using a 35 mm or medium-format camera, set the aperture to f/16. If using a view camera, set the aperture to f/32. Using a handheld reflected-light meter or the camera's meter, make an exposure reading from the card to determine the shutter speed. Set a shutter speed 6 stops faster than the shutter speed indicated by the meter. Maintain this shutter speed throughout the exposure test. For example, if the indicated shutter speed is 1/2 sec*, a shutter speed of 1/125 sec is 6 stops faster. If possible, avoid using a shutter speed faster than 1/250 sec, as faster shutter speeds are generally not quite as accurate as slower speeds.

*Shutter speeds longer than 1/2 sec will give unreliable results because of reciprocity effect.

Note: An exposure made at a straight meter reading of the card (whether it's light or dark) always produces a Zone V value—medium gray (see p. 62 for an explanation of how meters work). But we are trying to determine Zone I, the first full step away from maximum black and representative of the first usable effects of light on film. Theoretically if your system was in perfect working order, you would produce Zone I by underexposing 4 stops (Zone V minus Zone I = 4 stops). But since it's unlikely your system works perfectly, you have to do a series of exposures to find exactly where Zone I is with your camera system.

7. If using a view camera, pull the dark slide only halfway out for each shot to provide an area of blank film. Take the first picture of the gray card underexposing 6 stops. For the second picture, set the aperture between f/11 and f/16 (between f/32 and f/22 for view camera users) to make a 5 1/2-stop underexposure. For the third shot, if you will not be using a densitometer but are using roll film, attach the lens cap and shoot a blank frame. Shoot a blank frame after every two test exposures to make the test evaluation easier. Make seven more test exposures of the card (nine exposures in all). For each succeeding test exposure, increase exposure by 1/2 stop (smaller **f-number**), adjusting only the aperture ring. If you started at f/16, the final picture should be made at f/4. If you started at f/32 with a view camera, the final picture should be made at f/8.

8. Process the film in your favorite developer according to the manufacturer's instructions.

*For roll film users, your test roll should look like this. The first frame taken of the gray or matte card should be nearly clear, having only a slight or no visible density to it. Succeeding shots of the card should have increasingly higher density.*

### Evaluating the Test

You are looking for the frame with 0.1 density more than the unexposed (blank) frame. This frame will have a light gray tinge. However, there will normally be two or three test shots with an even lighter gray tinge (too little density) than this frame. An unexposed (blank) frame represents the lowest density possible with the film in use. Its density is usually referred to as base + fog. The base meaning the density of the material of the film base; the fog meaning the slight density added to the emulsion by chemical action.

If you have found a densitometer to use, measure the density* of the blank frame. Let's say it's 0.24 for 35 mm T-MAX 100 Film. Now find the test frame that gives a value of 0.10 above the density of the blank frame—in other words the frame with a density of 0.34; 0.34 = 0.10 + 0.24.

*Densitometer*

Photo courtesy Cosar Corp.

If you don't have a densitometer, use the No. 48 wedge of the KODAK Projection Print Scale. For a more reliable reading when using the projection print scale, trim the clear film away from the wedges on the projection print scale. View the film test frames on a light box or against a uniform area of the sky by taping the film to a window. Lay the No. 48 wedge of the projection print scale over the blank frames one by one and compare its density (added to that of the blank frame) to the adjoining test exposures until you find the test exposure that matches it in density. This test frame represents the required minimum exposure above the blank film. It assures that you will be able to obtain detail in shadow areas of a scene.

After finding the frame with 0.10 density more than the blank frame, determine how many stops it was underexposed (use the first test frame as a benchmark—it should have been underexposed by 6 stops). In the table to the right, find the factor corresponding to the amount of underexposure and multiply the factor times the ISO film speed used in the test. The resultant number is your system-speed number and should be set on your camera film-speed dial or meter whenever using this type of film. For example, if you used T-MAX 100 Film, EI 100, and the matching frame was 3 stops under-exposed, you should multiply the film speed by a factor of 0.5 according to the table. 0.5 x 100 = 50. You would then set the film-speed dial to 50 whenever using T-MAX 100 Film. Generally, most people find they need a number slightly lower than the film's rated speed, and sometimes your number will only be half that of the rated speed. A few people will need higher speeds, because of inaccurate shutter speeds or a meter bias.

Your system-speed number applies only to this type of film and camera and meter used. If you change the type of film or the camera, you should retest for

### *TYPICAL BLANK FRAME DENSITIES

| Film | Format | | |
|------|--------|-----|-------|
| | 35 mm | 120 | Sheet |
| T-MAX 100 | 0.24 | 0.11 | 0.08 |
| T-MAX 400 | 0.27 | 0.11 | 0.08 |
| TRI-X Pan | 0.32 | — | — |
| PLUS-X Pan | 0.27 | — | — |
| TRI-X Pan and PLUS-X Pan Prof. | — | 0.18 | 0.10 |
| Technical Pan | 0.18 | 0.18 | 0.18 |

Your densities may vary by a few hundredths due to developer choice, length of development, agitation, or densitometer calibration.

a new system-speed number. If you change meters, test that the new meter matches the old one in sensitivity, and adjust if it does not.

*After evaluating your results, set the new system-speed number on the film-speed scale of your camera or handheld meter.*

| Stops Underexposed | Multiply Film Speed by This Factor |
|--------------------|-----------------------------------|
| 6 | 4 |
| 5½ | 2.8 |
| 5 | 2.0 |
| 4½ | 1.4 |
| 4 | 1 |
| 3½ | 0.7 |
| 3 | 0.5 |
| 2½ | 0.35 |
| 2 | 0.25 |

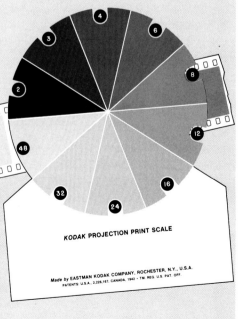

*If not using a densitometer, hold the No. 48 wedge of the Projection Print Scale over the blank frames of the test roll or the blank sheet film. Compare the combined density of the No. 48 wedge and the blank frame to the adjacent test frames until you find a match.*

KODAK PROJECTION PRINT SCALE

Made by EASTMAN KODAK COMPANY, ROCHESTER, N.Y., U.S.A.
PATENTS: U.S.A., 2,226,167, CANADA, 1942 • TM. REG. U.S. PAT. OFF.

## SYSTEM FILM-DEVELOPMENT TIME

Once you determine your system-speed number, you can find the film developing time that gives you the best results. The system-speed number is designed to give you detail in the shadow areas of the scene. The system film-developing time places detail in the appropriate highlights (light tones) of a scene. As previously mentioned, development has little effect on shadow areas—exposure mainly affects their densities. However, development greatly affects the highlights. Longer and shorter development times can easily lighten or darken highlights by one full zone step as represented by the Zone scale on p. 50.

Greatly increased development times may increase local contrast in shadows but will also severely increase overall contrast. Increased development also increases graininess, an effect most noticeable with smaller format films because they require greater enlargement.

**The goal of the development test is to find the developing time that preserves full detail in a Zone VII highlight with your system, including your enlarger, when printed on a grade 2 or equivalent\* enlarging paper.** This development time remains accurate only so long as your system components remain integral. Change something in your system and your development time may change. This is especially true for your enlarger.

If you are using the new KODAK T-MAX Films, note that they are more sensitive to development changes than other films.

\*If using KODAK POLYCONTRAST II Filters with a Kodak variable-contrast paper, the No. 2½ filter gives the equivalent of a grade 2 paper.

## THE DEVELOPMENT TEST

For this test you can use the same matte board or gray card used in the film speed test. You'll need 5 rolls or sheets of film. If you load your own roll film, use short rolls of 12 exposures (see roll film procedure on p. 57), otherwise buy short rolls. You'll also need either a densitometer or the KODAK Projection Print Scale.

1. Set the matte board or gray card in **uniform** light outdoors.

2. Use the same film as in the previous test, and set your new system-speed number on the camera or meter.

3. Take a meter reading from the gray card (or matte board), being sure that the meter reads only from the card. Increase exposure 2 stops above the meter reading (Example: If meter indicated shutter speed is 1/125, use 1/30; or if indicated aperture is f/16, use f/8). Avoid shutter speeds faster than 1/250 sec.

4. Shoot 5 rolls of film as follows. Make several (5 or 6) exposures of the gray card at the settings indicated in step 3. Then shoot a blank (unexposed) frame with the lens cap in place. Don't simply leave the rest of the roll blank or film developer may become too active since it would be working on fewer images. Instead, quickly shoot some random subjects nearby—anything to expose the film. With sheet film, expose 5 sheets as described in step 3. Pull the dark slide halfway out for each exposure to provide an area of blank film.

5. Keep careful notes of the development times used for each roll or sheet.

6. Develop the first roll or sheet according to the manufacturer's time/temperature recommendations or to the time that gave you good results in the past.

7. Using the same temperature as in step 6, develop the remaining rolls or sheets as follows.

Roll 2: Increase development time 15% (10% for T-MAX Films)

Roll 3: Increase development time 30% (20% for T-MAX Films)

Roll 4: Decrease development time 15% (10% for T-MAX Films)

Roll 5: Decrease development time 30% (20% for T-MAX Films)

*This is the proper agitation technique for small-tank development of T-MAX Films. Extend your arm and vigorously twist your wrist 180 degrees to invert the tank. Invert the tank 5 to 7 times during a 5-second period. Perform this agitation at 30-second intervals. This technique can also be used with other black-and-white films.*

### Evaluating the Test

If you have a densitometer, use it to measure the density of an unexposed (blank) frame. Add the density of the blank frame to 1.05 if you have a diffusion enlarger, or to 0.80 if you have a condenser enlarger. Using the densitometer, find the roll or sheet with the Zone VII negative that most closely matches this sum. **The development time for this roll represents your system development time.** For instance if the unexposed (blank) frame has a density of 0.30 and you have a diffusion enlarger, add 1.05 to 0.30 = 1.35. You should find the roll with Zone VII test frames that have a density of approximately 1.35. If you are within ±0.07, you are in good shape. If not, you'll have to repeat the test, increasing development time if you need greater density, shortening it if you need less.

If you don't have a densitometer, use the KODAK Projection Print Scale. Use the No. 4 wedge if you have a diffusion enlarger and the No. 8 wedge if you have a condenser enlarger. For more accurate comparisons, you may want to trim the clear film away from the circle of wedges on the projection print scale.

Now examine the rolls to find the one with proper development. View the test films on a light box or against the sky by taping them to a window. Lay the appropriate wedge over the blank frame and compare its density (added to the blank frame) to the adjoining test exposure on each roll until you find a match. The development time used for the roll that provides the closest matching frame is your system development time. If you cannot find a close match, repeat the test; this time increasing development by 50% above the manufacturer's recommended time if your best test exposures were too light and decreasing by 50% if they were too dark. With small- and medium-format films, large increases in development may so increase graininess as to make resultant prints unacceptable. If your development time is 50% (30% for T-MAX Films) greater or less than that used in the film-speed test, you should redo the film speed test using the new development time. Great changes in development can affect density in shadow areas. Such large changes in development time may also indicate that you incorrectly established the system-speed number and should again evaluate your exposure test (p. 52).

See page 57 for a "Reality Test" in which you photograph one of your typical subjects as a final proof of your exposure and development tests.

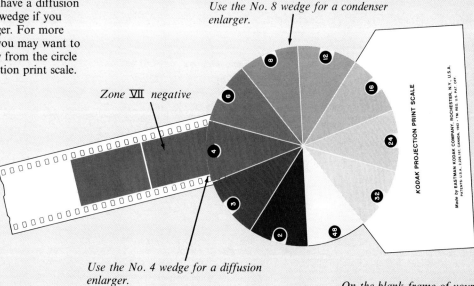

*Use the No. 8 wedge for a condenser enlarger.*

*Zone VII negative*

*Use the No. 4 wedge for a diffusion enlarger.*

*If you used roll film, your roll of test negatives should resemble this example.*

*On the blank frame of your test roll, overlay the appropriate wedge from the projection print scale. The density of the wedge and the blank film frame should match the Zone VII negative.*

## PRINT DEVELOPMENT TEST

The printing test ties together the exposure and development tests. Printing is the proof of how successful you have been, whether in tests or in making actual photographs. **The goal of the printing test is to find the minimum exposure time that will produce a maximum density (black) in the print from a blank processed negative (one of the unexposed test frames).** The resulting minimum exposure, once again, includes all the variables of your print-making and camera system. With other correctly exposed and developed negatives, this exposure time should render a clear and accurate separation of tones with desired detail or texture in shadows and highlights, provided that enlarger height, paper, paper grade, and lens aperture remain constant.

For the most accurate testing, use the print size (and enlarger height) at which you intend to make most of your later prints. Major changes in magnification may invalidate these test results.

### PRINTING TEST

1. Use your favorite paper in a fixed contrast of grade 2. If using KODAK POLYCONTRAST II Filters with a Kodak variable-contrast paper (such as POLYFIBER Paper), use the No. 2½ filter to obtain the equivalent of a grade 2 paper.

2. Insert one of the clear (unexposed) negatives halfway into the negative carrier of your enlarger. Focus the bright area on your enlarging easel using a grain magnifier. Alternatively, set focus using a negative with a real subject prior to inserting the blank negative. **For sheet film to be contact printed:** Cut a 1-inch square from the middle of an unexposed, processed sheet, and contact print the sheet.

3. For improved optical performance, set the enlarger lens to two stops smaller than the maximum aperture (to f/5.6 if maximum is f/2.8). On the resulting print, the area exposed through the film and the area not exposed through the film will be side by side for comparison.

4. As a starting point, make an exposure test series at 5-second intervals, beginning with a 10-second exposure and ending with a 30-second exposure (exposures of 10, 15, 20, 25, and 30 seconds). Use an individual sheet or cut-up piece of enlarging paper, and make a full and separate exposure for each piece.

5. When this exposure series has been processed and dried, find the maximum black produced by the minimum exposure time. This is the first print that shows no visible density difference between the areas of the print exposed through the film and not through the film. The exposure time for this print is the minimum exposure time that will produce a maximum black. If you like, you can now more accurately pinpoint the minimum exposure time by making 2-second brackets around it and again choosing the print that yields black of identical densities in each area of the print.

6. When all else is constant, this minimum time should give a good starting point for making prints from your future system negatives.

*Through empty carrier*    *Through negative*

*10 sec*

*In the print exposed for 10 seconds (far left), the area exposed through the negative is not quite so black as the area exposed through the empty carrier. In the prints exposed for 15 and 20 seconds, the blacks of both areas are equally dense. Thus 15 seconds represents the minimum exposure time that produces a maximum black because it is the shortest exposure time that produces a print with maximum blacks in both areas.*

*15 sec*

*20 sec*

## ADJUSTMENTS FOR ROLL-FILM AND 35 mm PHOTOGRAPHY

With sheet film, you can easily customize development for each individual subject photographed. Such is generally not the case with roll film. Even though a roll of film is likely to have many different subjects on it, you are usually forced to give that roll of film one development time. The time might be perfect for some subjects, for others it may extend negative contrast too far, and for others not far enough.

If you are a roll-film user, whether 120 or 35 mm film, you need a scheme so all your negatives will print easily and with the tonality you want. There are two solutions. The best solution is to confine each roll of film to scenes of similar brightness ranges. For instance, on one roll you shoot only scenes with a high brightness range. On another you shoot scenes only with a normal brightness range. You don't mix scenes of drastically different brightness ranges—a foggy farm scene and a sunny ski slope. By limiting the roll to scenes of similar brightness ranges, you can then select a development time that will give the ideal negative contrast for all the scenes on the roll. This method will result in prints with a greater range of tonality than the next method.

This method is more easily used if you load your own film (or use 120-size film and/or different backs for medium-format cameras). By loading short rolls, say 12 exposures, you won't be wasting much film when you want to change rolls to photograph a scene with a different luminance range. As soon as you unload the film from the camera, mark it to indicate whether it should receive more (+), less (−), or normal (0) development.

The other method is simply to shoot any scene you want using full rolls of film—when unloading the film, mark the roll for the development time it is to receive. If the roll includes scenes with a high-brightness range (contrasty scene), develop it 30% less (15% less with T-MAX Films) than your normal personal development time. If you come across a contrasty scene in which you aren't worried about preserving shadow detail, you can capture more highlight detail by reducing exposure 1 stop.

If the roll does not include any scenes with a high-brightness range, use your normal development time, or even extend development time if most of the scenes are of a low-brightness range. Again, mark each roll for development as soon as it is removed from the camera. You might want to keep notes of the types and importance of scenes included on a roll in case there's one image you really want to be developed just right.

The goal of this last method is to avoid producing a negative with highlights so dense that they cannot be printed. A normal- or low-contrast negative should result. Because the contrast grading systems for enlarging papers that occur in fixed grades provide more flexibility for the flat negative than for the contrasty negative, you'll find it easier to make good prints from a normal or flat negative than from a contrasty negative. Avoiding a contrasty negative is not as much a problem if you use one of the Kodak variable-contrast papers with KODAK POLYCONTRAST II Filters. Starting at 0, these filters provide half-grades up to 5 (0, $\frac{1}{2}$, 1, $1\frac{1}{2}$, 2, $2\frac{1}{2}$, 3, $3\frac{1}{2}$, 4, $4\frac{1}{2}$, 5). The No. $2\frac{1}{2}$ filter is considered normal. Since the $2\frac{1}{2}$ filter is centered in the series, you can handle high- and low-contrast negatives with equal facility.

In using these methods, all your previous testing remains valid.

### A REALITY TEST

If you have achieved the negative densities required by the tests, you should be in good shape. But one final test lays ahead, a test that can be made at your convenience. It is the true test—a real subject, a subject that is not a gray card or a matte board, but a person or a landscape, a real subject that you would normally photograph.

When next out photographing, carefully employ all the results of your testing. Set your camera or handheld meter to your new system-speed number (using the same film and equipment as used in the tests). Photograph a subject that you would normally choose (one of normal contrast, unless you would normally photograph subjects with extreme contrast). If it is a person with Caucasian skin, take a close-up reading of the face and open up 1 stop from the meter reading.

When done photographing, develop the film according to your system film-development time. With the resulting negative you should be able to make a high-quality print on grade 2 paper or equivalent (half grade variation is okay, too). Set the enlarging lens to the same height and to the same aperture as for the original test; use the same paper, developer, and development time as used for the original test.

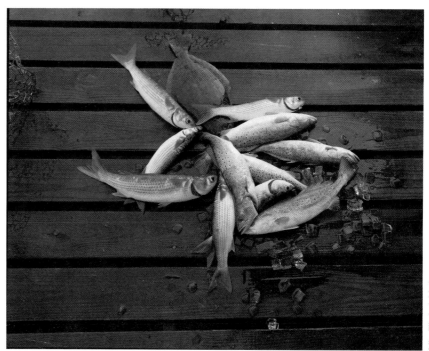

*Although their appearance is vastly different, these three prints were made from negatives exposed in the camera in the same manner—the darkest shadow area with significant texture (equivalent to a Zone III gray) was measured with a reflected-light exposure meter. Subtracting two stops from the meter recommendation gave proper exposure for important shadow detail. The widely divergent highlights (none apparent in the tree roots image) were ignored for exposure, but were measured and recorded for individual development later.*

Miss Elizabeth Motlow

*Normal brightness range: normal development*

## ADJUSTING FOR BRIGHTNESS RANGE OF A SCENE

The objective is to correspond the scene observed with the density range possible in the negative and to the resulting tones in the print. Certain values in the scene are fixed, such as the brightness of different areas in the scene and the resulting range of values from deep shadow to bright highlight. For any given situation, this range of values can be reasonably translated from scene to print, because, although the scene values may be fixed, the photographic system is flexible enough to contain all but the most extreme conditions.

Black-and-white films are usually exposed to capture detail (texture) from Zone III to Zone VII inclusively. If you subtract Zone III from Zone VII, you find there is a 4-stop difference, which is considered normal. The number of stops difference between the highlight zone with detail and

Zone III indicates whether a scene has a normal, high, or low brightness range. Sometimes lower shadow values and higher highlight values will exist in small areas, insignificant within the context of the entire scene, but it is possible that you may wish to extend the range of the system or condense it to accommodate situations with a greater or smaller range of values.

When important highlight details in the scene exceed Zone VII, the logical procedure is to expose the important shadow areas correctly and compensate for the highlights by reducing development, which, in turn, has little effect on the shadow areas. The reduced development brings the highlights back close to Zone VII. (It is important to remember that if you elect to record detail in bright highlights and deep shadows, the overall

contrast of your resulting print will appear to be less than that of the scene you photographed.) This procedure is ideal for sheet film where you can custom develop each exposure. It will work well for 35 mm film only if the entire roll is exposed to scenes with similar brightness ranges.

To maintain the highest fidelity and to obtain the most accurate rendering of a scene, the first step is to establish exposure based upon the significant-detail shadow reading. Assuming you want the shadow detail area to be rendered as a Zone III value, take a reading of the shadow area. To obtain that Zone III value, give two stops less exposure than indicated by the meter.

The second step is to establish an appropriate development time using the procedure at right. Decide whether development should be longer or

*Low brightness range: extended development*

Owen Butler

*High brightness range: less development*

Owen Butler

shorter than normal. The table below gives starting factors to adjust negative development for the brightness difference in a scene. Remember that T-MAX Films require smaller development adjustments—usually 10 to 15% compared to 30% for conventional films. Experience or further testing on your part may indicate you need to adjust the factors in the table.

## DEVELOPMENT FACTORS

| Brightness Difference | Development Factor |
|---|---|
| 4 stops (Normal) | 1.0 |
| 3 stops (Flat) | 1.3 (1.15)* |
| 5 stops (Contrasty) | 0.7 (.85)* |

Multiply your system development time by the factor indicated.

*Use this factor for T-MAX Films.

## DETERMINING THE BRIGHTNESS DIFFERENCE OF A SCENE

Use a reflected-light meter. Meter the brightest and darkest areas that you want to show full detail in the print. Once you find out the brightness difference (in stops) between these two areas, you'll know whether to lengthen, maintain, or shorten film development to alter negative contrast. The best meter for this job is a spot meter, but you can also perform it with a handheld meter or a built-in camera meter. Unlike camera meters which usually give readings in f-stops and shutter speeds, spot and handheld averaging meters often give readings in whole numbers. This procedure is not for determining exposure. It is only for measuring the brightness difference of a scene in stops. Here's how to do it.

1. Meter the brightest highlight which you want to show full detail in the print. For the spot meter, let's say the readout was 15. For the camera meter, let's say it was 1/125, f/16.

2. Now meter the darkest area you want to show texture in the print. Note the meter reading given by this area. Let's say the readout was 10 for the spot meter and 1/125, f/2.8 for the camera meter.

3. Determine the difference in stops between the two areas. For the spot meter, simply subtract the low number from the high. (15 - 10 = 5). For the camera meter readings, since the shutter speed remained the same, we can simply count down by full stops (not including f/16) from f/16 to f/2.8—f/11, f/8, f/5.6, f/4, f/2.8. In both cases there is a 5-stop difference between the bright and dark areas we wish to reproduce with detail in the print. This is somewhat contrasty so we will reduce film development as indicated by table at left.

**Note for Camera Meter Users:** By setting the aperture to f/16 for the highlight area (and letting the shutter speed fall where it may), calculations are simplified. When you meter the shadow area, simply note the new aperture indicated. (keeping the shutter speed the same). To find the brightness difference you now only have to count full stops backwards from f/16 as shown in step 3.

Exposure—minus 2 stops;
development—plus 50%

Print from underexposed and
overdeveloped negative

The two examples at top show that no
remedial action (such as over-
development) will recover detail from
textured shadow areas in an
underexposed negative. The converse is
not true, however, for underdevelopment
of the highlights in an overexposed
negative. Compensation in developing
will often save an overexposed negative.
It's easy to understand those hoary old
photographic homilies, "Overexpose and
underdevelop" or "Expose for the
shadows and develop for the highlights."

The examples below show a scene with a
normal brightness range (4-stop
difference between areas chosen to have
highlight and shadow detail) printed on
No. 2 grade paper. The larger
photograph was retouched to show its
tones in the form of the different zones.

Print from normally exposed and
developed negative

Normal exposure, normal development

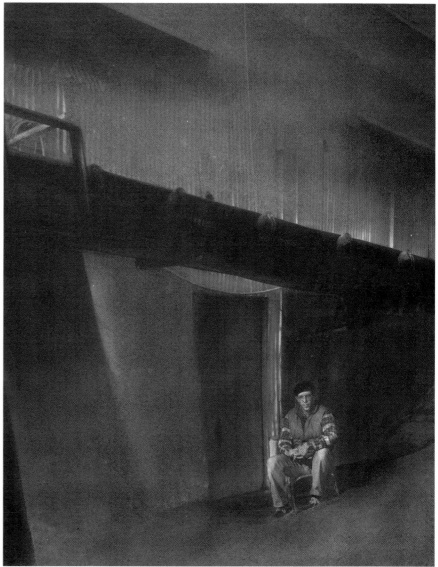

Owen Butler/Mary Donadio

## Scene with Low Brightness Difference

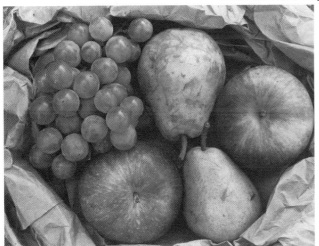 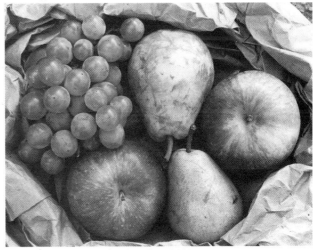

*Print from normally developed negative*      *Print from negative developed + 30%*

 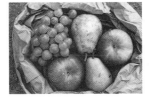

*The larger photos were printed on the same grade paper, but the enlarging time was adjusted to match the midtones in the photos. This leaves you to judge the contrast difference created by film development. The smaller photos were printed on the same grade paper and at the same enlarging time. They show the effect of film development on negative densities. By changing paper grades, prints from the normally developed negatives could be improved.*

*Print from normally developed negative*      *Print from negative developed − 30%*

 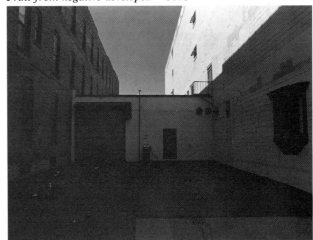

## Scene with High Brightness Difference

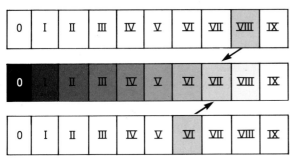

| 0 | I | II | III | IV | V | VI | VII | VIII | IX |

*Less development*

| 0 | I | II | III | IV | V | VI | VII | VIII | IX |

*Normal development*

| 0 | I | II | III | IV | V | VI | VII | VIII | IX |

*More development*

*These zone scales show how increased and decreased film development mainly affect the midtones and highlights. Print densities are shown in the scales.*

## USING YOUR REFLECTED-LIGHT METER

All your testing will be to no avail if you do not know how to use an exposure meter. You should use a reflected-light meter because only with it can you seperately measure light reflected from dark and light subjects in the scene. Reflected-light meters come in two basic formats—handheld and built-into the camera. And within both these formats are two types—the averaging meter and the spot meter.

The averaging meter reads light reflected from a large area of the scene. In the case of those built into the camera, the meter normally reads the area seen by the lens. Some built-in camera meters are center- or bottom-weighted. This means the meter gives more emphasis to the center or bottom of the subject as seen through the viewfinder. To obtain accurate meter readings, you often must move in close so that the subject fills the viewfinder. Be careful that your body does not block light from reaching the area being metered—if it does, your meter reading will be wrong.

Spot meters read a narrow area of the scene selected by you. Handheld spot meters typically have a viewing area of 1°. The viewing range of spot meters built into the camera is usually a bit wider, 3° to 12°. The advantages of spot meters over averaging meters are that you know exactly what part of the scene you are measuring and you can meter those areas from many yards away.

Some of the latest 35 mm cameras have programs built into their exposure systems that evaluate scene reflectance or can accumulate a number of meter readings to "average" out parts of the scene as you see fit. Although these systems usually work well, you may not be aware of the compromises they're making. This uncertainty undermines all your testing. So if your camera has such an option, you'll probably obtain greater accuracy for fine black-and-white work by using straightforward metering, either spot or averaging.

Meters measure light. Through electromechanical devices their readings of light are converted into exposure recommendations. The exposure recommendations are based on the assumption that film needs only enough light to make a well-exposed photo of a scene of average reflectance. A scene of average reflectance would likely be your grassy backyard on a sunny day with a few people scattered about, some in the shade, some by the pool. Purée that average-reflectance scene, shadows, highlights, and midtones, into a uniform mixture and you come up with a blend that reflects about 18 percent of the light—or a gray card.

So as long as you photograph average scenes, your meter will give good results. But get away from the average and trouble is headed your way. What's away from the average? Black is. White is. Dark gray, dark green, dark anything is. Light gray, light blue, light anything is. Mixtures of bright and dark are. All of these break from average reflectance.

When you are faced with highly or lowly reflective scenes, remember that the meter will suggest an exposure that will reproduce them as average reflectance. It will make a sunlit field of snow gray; it will make tar gray.

To keep a highly reflective scene, such as snow, from appearing gray, you need to let in more light than suggested by the meter. Referring to the gray scale on p. 50, we can gauge that snow is about Zone VII, two zones above the Zone V so beloved by the meter. If you remember, for our convenience, each zone was made to be one stop of exposure apart. So for the Zone VII snow to appear nearly white in the print, it requires 2 stops more exposure than the meter indicates. Caucasian skin is normally Zone VI, requiring a 1-stop exposure increase

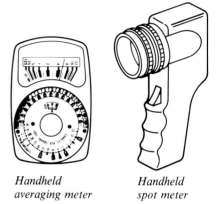

*Handheld averaging meter*  *Handheld spot meter*

*Camera with built-in meter*

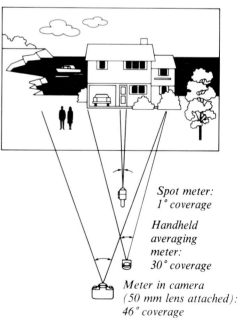

*Spot meter: 1° coverage*

*Handheld averaging meter: 30° coverage*

*Meter in camera (50 mm lens attached): 46° coverage*

*Only with a spot meter can you measure the brightness of small areas from a distance. You can narrow the measuring angle of a camera's built-in meter by using a telephoto lens for metering specific areas. A 200 mm telephoto lens covers only a 12° angle compared to 46° for a 50 mm lens.*

when taking a close-up reading of the skin. Black skin is typically Zone V and needs no adjustment (unless person is unusually light-or dark-skinned) because it corresponds to the meter which is set for Zone V.

More difficult than adjusting for a meter's medium gray bias is metering a scene of high contrast—a sunny scene with bright highlights and dark shadows. The difficulty is not so much in metering as in deciding which highlight and shadow tones should show some details in the print.

Imagine an oak tree next to a light gray house in sunlight. How do you determine exposure? You first find which details are important to you. Let's say detail is important both in the shadows (tree trunk) and in the highlights (the sunlit house). Since you need shadow detail, you have to base exposure on the shadow area. Take a reading from the trunk. Since it will be the darkest area to reveal detail, let's decrease the Zone V exposure 2 stops to make it a Zone III value (dark gray). Then determine the brightness difference of the scene and develop the film according to the table on p. 59. The development should enable you to hold highlight detail.

If you did not care about showing shadow detail, but only wanted the house to remain light gray, you would meter directly off the house. Since light gray is about 2 stops brighter than the Zone V medium gray for which the camera would set the exposure, you would increase exposure 2 stops and develop the film normally. Although the house tonality would be correct, the trunk of the tree would be quite dark, possibly without detail.

In metering a high-contrast scene you need to decide which subjects are important and to expose accordingly. Then you need to find the brightness difference from the highlight details to the shadow details. If the difference is not normal, alter development (see table on p.59).

*Exposure indicated by meter*          *Adjusted exposure*

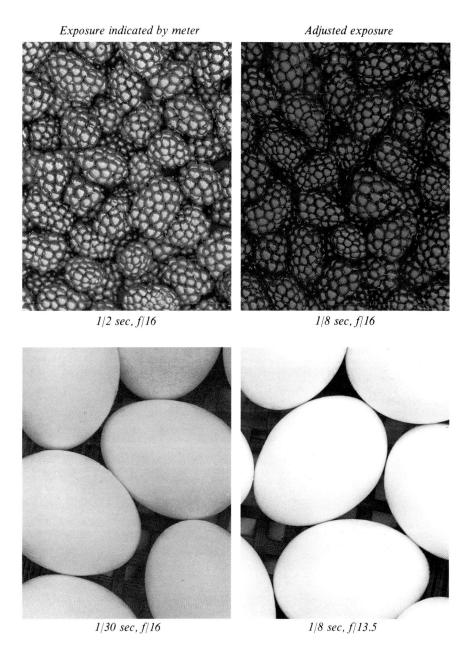

*1/2 sec, f/16*          *1/8 sec, f/16*

*1/30 sec, f/16*          *1/8 sec, f/13.5*

*Here's proof that a reflected-light meter tries to make everything gray. Exposed at a straight meter reading both blackberries and eggs appear gray. For blackberries to appear realistic, exposure was decreased 2 stops (less light). For the eggs to appear white, more light was required for the film—exposure increased 2 1/2 stops.*

## THE GOLDEN RULE:
### Expose for the shadows

The golden rule of black-and-white photography is to expose for shadow detail. Find the darkest part of the scene which has details you want to show in the print. Take a meter reading of just that area. The shadow area to show detail is normally considered as Zone III. Since Zone III is 2 stops less than Zone V, you should reduce exposure by 2 stops from the meter reading of the shadow area (a shutter speed of 1/125 if 1/30 is indicated or an aperture of f/16 if f/8 is indicated). Use your normal film development time unless the scene has a high or low brightness difference (see p. 59).

## PRINTING

Making a print is the final major effort. Although printing demands the greatest challenge of judgment and craftsmanship, it compensates by providing visual control of the results. This observation of work in progress allows for immediate gradual or major modification as you work from one print to the next, refining all the time.

Unfortunately, printing implies magic—the hope that all previous error or miscalculation in the process will be corrected and successfully remedied. Although most reasonably exposed negatives are printable, many prints are unacceptable for reasons that are beyond the control of the printing process. And the photographer must realize that the final print may be an entity totally removed from the original scene.

All of the exercises discussed on previous pages for negative exposure and developing are aimed at giving you a negative that will print well on a normal contrast grade of paper. Also, as previously discussed, some scenes may have to be compromised in the film development (particularly with roll film) so you will have to use a more contrasty paper or filter with a selective-contrast paper. A reasonably exposed and developed negative is an excellent springboard for quality printing. The real craftmanship begins after you have a satisfactory work print.

You should approach printmaking in the following order: First, determine overall print exposure density. Then, establish a scheme to treat local density with dodging and burning. Finally, if needed, make a contrast grade change. Small increases in exposure can increase the appearance of contrast. A major change in contrast may require further local dodging and burning.

Controlling exposure in problem areas through dodging and burning gives the photographer the tonal grammar for producing a satisfactory image. A striking print is not necessarily the result of careful measurements, but of incremental changes based on as-you-go judgments. These impressions and decisions are also a product of the moment—later prints from the same negative may differ greatly and be equally pleasing to the photographer.

### MAKING THE PRINT

1. Insert a negative into your enlarger carrier. Make sure that the negative, enlarger lens, condensers, and the carrier housing are free from dust.

2. Insert a piece of paper similar in weight to the enlarging paper you will be using into your easel. Compose and focus the image.

3. Make a test print. The exposure time and aperture found by the maximum density/minimum exposure time test should be a good start, provided the enlarger height is approximately the same. After partial fixing, view the print in light with a brightness similar to your display area, and make your exposure judgement. Use a bright enough light for making this decision and bear in mind the effects of drying and post-processing treatments. Dry-down will make a print slightly darker.

4. Make your first work print. Partially fixed, use the same inspection light as for the test print to make judgments about local treatment for density. Number this and all succeeding prints and keep score in a notebook about what you do with each print.

5. Make a second work print and apply dodging and burning as needed. It is helpful to divide total exposure into discrete blocks that allow you to perform whatever manipulation is necessary.

   For instance, if you think that area A needs increased density, give extra exposure by burning as a separate additional increment to the total exposure. If you think that area B needs less density, make the dodging time separate from the

Miss Elizabeth Motlow

remainder of the total exposure. This would give you three exposures to set on your enlarger timer. The first would be the total exposure minus what you'll allow for dodging. The second exposure would be the remainder of the total exposure that you've set aside for dodging area B. And the third exposure would be time committed solely for burning in area A.

This procedure seems an overly complicated way to treat a reasonably simple printing problem. But as a print becomes more complicated, you may be trying to solve problems in several areas. Segmented timekeeping helps you keep organized and keeps your records straight. It's easier to make changes in the succeeding print, because you know exactly what you did on the preceding one.

6. If the print is still not satisfactory, it may be time to change contrast grade or filter and start over again. Many variable-contrast papers require a change in exposure, as do some single-grade papers. Consult the paper instructions, and change your exposure or make another test strip. Your first working print with the changed contrast may show a different set of areas that need manipulation. Follow the procedures above.

7. When you have the final print, complete the processing and let it dry. If the dry print is satisfactory, you're finished. If not, you may need to make a small overall change. One thing that will help this determination is to match your inspection lighting to the lighting where the print will be displayed.

Some display areas are bright, others dim. Your choice of paper base and image tone may depend on whether the print will be lighted with tungsten, fluorescent, or daylight. Papers with fluorescent brighteners, such as POLYFIBER Paper, will seem brighter under light rich in ultraviolet radiation such as daylight and fluorescent lights.

8. When you have made your best print, you may want to make several prints exactly alike for later use, or slightly different for different display conditions. It's handy to have several—you may want to apply post-processing techniques to some of the prints, and it's wise to have backups in case of mistakes. You may also need them for different purposes—multiple displays, portfolio, and décor, for example.

Tips on finishing techniques such as reduction, toning, and retouching, are given in following pages.

*A working sequence of prints with a variety of manipulation such as the examples above bears out the contention that printing is the second making of a photo—one with greater control, and one that is more rewarding for many photographers. Here, minor changes through dodging and burning could not produce what the photographer felt was the best image. The next logical step was to cut a dodging mask that allowed precise and separate exposure of both background and subject areas through the 8 x 10-inch negative to the contact print beneath.*

## PRINT CONTROLS

We've breezed through print manipulation techniques such as dodging and burning-in without any concrete advice. Although some people rely solely on their hands to block light when dodging and burning, there are some tools and techniques that will make your job easier. Naturally, if there is no information on the negative in underexposed shadow areas or blocked up highlight areas, it's virtually impossible to create something on the print.

### Dodging

Dodging means restricting light from areas of the print that would be too dark with full exposure. Many photographers adapt their hands to fairly intricate dodging tasks. Handwork is imprecise at best and often leads to uneven density in the print.

Although you can buy dodging and burning kits, you may prefer to make your own. The first item you will want is thin, stiff wire, such as a bicycle spoke or a coat hanger, for the handle. The black cardboard found in enlarging paper and sheet film boxes is ideal for making the shapes you will attach to the wire handles.

Typical shapes for dodging tools are circles and ovals. Some people prefer to serrate the edges to avoid leaving any evidence of the technique in the print. For large, unusually shaped areas, you may want to cut a special tool that will keep your movements to a minimum and insure even density throughout the area being treated.

As stressed on the preceding pages, it's helpful to set aside discrete portions of exposure time for dodging tasks, particularly if you have several areas to treat. You might want to stop down the enlarger lens to give yourself enough time to do the job right (but not so much as to impair lens performance). Keep your tool moving all the time, up and down as well as back and forth to avoid any obvious indication that you've been dodging. For big areas, raise the tool toward the lens. For small areas keep it close to the paper and move the tool faster. Start cautiously. A little dodging goes a long way.

### Burning-In

Burning-in employs a hole to increase density of small areas beyond that given by the main exposure. Several sheets of black cardboard with different sized and shaped holes should serve your needs well. Again, you may want to cut special tools for unusually shaped areas.

Burning-in time should also be set aside from your basic exposure time. Once your main exposure is complete, set your timer for the small amount of extra exposure you want for burning-in. Use the time for burning only, being careful not to allow extra exposure on other parts of the print. Keep the tool moving all the time and move it faster when close to the paper. If the rest of the print is correctly exposed, you shouldn't need much more exposure.

### Masking

For people who contact print large format negatives, pencil masking affords more precise control over small areas of the print. The idea is to reduce light transmission with layers of mat acetate, carefully cut to the shapes of the areas being treated.

*In this case, subtle dodging and burning provided the desired emphasis that gave the photographer his final print (right).*

*Contrast grade #1*

You start with a dry working print. Lay a sheet of mat acetate on the print and with a soft pencil, lightly trace outlines of the area where you desire density withheld. Cut one or more layers depending on the amount of withholding desired. Lay the acetate carefully into position above the glass of the contact printing frame. The idea works well in reverse if you want to burn a section of the print—merely cut the acetate to cover the rest of the print, leaving the area needing additional exposure open to the light.

Naturally, this is a trial-and-error procedure. In a typical situation you will soon discover how to create a variety of exposure changes. Although slow, this procedure can give exact results. And when you file the negative with your printing calculations, add the masks for that negative. When you print it again, you can match your previous results without further experimentation. The same technique can be applied to enlarging 4 x 5-inch negatives. Place the masks (drawn from a contact print) gently on top of a glass negative carrier. (Beveling the edges of the acetate with a sharp knife helps to reduce evidence of tampering.)

### Reduction

Local and overall print control does not end with processing. Print reduction is an additional tool that may save you hours of frustrating printing. With a product like KODAK Farmer's Reducer you can take a print wet from the wash, freshly dried, or emerging from a decade of storage and lower the density overall in a tray or selectively with a spotting brush.

Follow the instructions for dilution. Pull your print a little before the desired reduction is complete. It will continue to work for a short time before stopped by a wash of water. The reduction is irreversible, so go careful-ly. Pay attention to the age of your solution. Older solutions need less dilution than fresh ones. Once you have accomplished the desired reduction, stop the process in a water bath, then refix and wash the print.

*Contrast grade #2*

### CONTRAST

Making an overall change in print contrast with filters or paper grade is a simple step you should take when you are in doubt about the contrast. With film you expose for shadows and adjust contrast by developing for the highlights. With paper, you pretty much reverse the procedure. You expose for highlights and adjust shadow density by changing the contrast of the paper.

There are two avenues for changing print contrast. The traditional path is to use a paper that can be purchased in a range of contrast grades—from very contrasty (grade 5) to fairly soft (grade 1). Or, it may be more convenient to use a variable-contrast paper with a series of below-the-enlarger-lens filters (or dichoric filter combinations in a color-head enlarger) that offer a range of contrast grades.

Variable-contrast papers like KODAK POLYFIBER Paper bypass keeping an expensive paper inventory. Moreover, they allow you to make local contrast changes in a print, just the same way you would dodge or burn in. Make a partial base exposure overall. Then adjust different areas by burning with different filters or by changing the enlarger-lens filter and dodging particular areas.

Many modern papers feature matched speeds with a whole series of filters. The set of 11 KODAK POLYCONTRAST II Filters provide $\frac{1}{2}$-grade increments and are speed matched. Grades 0 to $3\frac{1}{2}$ have the same speed and require no exposure change when switching among those grades. Grades 4, $4\frac{1}{2}$, and 5 require 1 stop more exposure.

*Contrast grade #3*          Miss Dana Hunter

## PHOTOGRAPHIC PRODUCTS

One of the most amusing facets of any photographic discussion is the intense feelings aroused by the mention of software. For every photographer there is an ideal film, a superior film developer, the only paper, and the perfect paper developer. Hearsay, myth, superstition, and opinion dominate the field.

But each film, developer, paper, and paper developer was created to fit a specific need or desire. Each has intrinsic qualities apart from the chauvinism that make it suitable or ridiculous for a given application.

### Film

Film is available in a wide variety of emulsions and bases appropriate for an equally wide variety of picture-taking activities. Generally, the difference lies in sensitivity. Slow-speed, fine-grain films are contrastier than medium-speed films that display slightly coarser grain. High-speed films show more grain with enlargement and are relatively lower in contrast. These considerations generally separate the roll films.

Because KODAK T-MAX Professional Films use the KODAK T-GRAIN Emulsion, they give substantially better quality than conventional films of comparable speeds. The T-GRAIN Emulsion uses silver halide grains that have been specially reshaped into a tabular form with greater surface area and thus greater sensitivity to light. T-MAX 100 Professional Film has finer grain than PANATOMIC-X Film, ISO 32. T-MAX 400 Professional Film has finer grain than PLUS-X Film, ISO 125. With T-MAX Films you can approach large-format quality even while using 35 mm or 120-size films.

### Roll Film

Subjects and shooting situations should determine the film choice. If you shoot a wide variety of subjects under an equally wide range of lighting conditions, you'll probably use a variety of films. If you tend toward landscapes, chances are good that you'll stick with one film. The best guideline for choosing a black-and-white roll film is to use the slowest film possible for convenient exposures, unless you have some overriding need for an unusual effect, such as enlarged grain.

### Sheet Film

There are more sheet films available because there are more specific purposes defined by the manufacturer. Although there may seem to be several films with identical speeds, they are usually separated by purpose and characteristic curve—the graphic indication of a film's emulsion response to different exposure conditions. Some films are intended for the completely controllable conditions of the photographer's studio. Others in the same speed range are offered for the location photographer who has little control over the ambient conditions. One film is distinguished from similar films by a base intended for easy pencil retouching for portraits. Your specific needs should determine your film choice—not legend or rumor.

### Film Developers

Film developers, like the films themselves, are intended for well-defined purposes. Some are relatively slow, permitting fine-grain rendition at a slight reduction of film speed. Others are faster, permitting shorter developing times. Faster, more active developers admit full film speed, but at the cost of slightly coarser grain. Some developers are aimed at small tank, one-shot development, while others are intended for replenishment in large tank or machine situations. Most film processing instructions recommend certain developers. Some film and developer combinations are not recommended.

KODAK T-MAX Developer is a fine liquid concentrate designed for normal or push processing. It can be used with all panchromatic films, not just T-MAX Films. Because it actually increases shadow detail, T-MAX Developer is excellent for push processing films. Other popular Kodak developers include KODAK Developer D-76 and KODAK HC-110 Developer.

Frequently, there are several developers that will accommodate a particular film and situation. One might be packaged as a powder and another as a liquid concentrate. And for a number of developers, there are several dilutions that provide varied results.

The best way to choose a particular developer for your photography is to use one that is recommended for your film. You may want to experiment with several to find the one that gives the best results and is the most convenient for your unique requirements. Again, the KODAK Data Book, *KODAK Professional B/W Films* (F-5), is an excellent resource for matching a Kodak film and a Kodak developer.

### Printing Paper

Printing software is also framed in a casual mythology, bolstered by frequent endorsements and heavy advertising. Once again, enlarging papers and developers are manufactured to fit particular purposes. Using these products out of context will usually give disappointment.

Choose a paper for image and base tone, as well as density range. (Some papers give greater maximum density than others.) Other considerations, such as speed, weight, and surface texture will no doubt influence your decision. Some papers, such as KODAK EKTALURE Paper, are warm toned and richly textured for portrait use. Others use a brilliant white base with an image of neutral tone and far-reaching maximum density, typically associated with gallery display.

A fiber-base paper is usually chosen when the highest quality print is needed. Fiber-base papers are considered to be more stable and to have more pleasing surface characteristics.

KODAK ELITE Fine-Art Paper and KODAK POLYFIBER Paper are two excellent fiber-base papers. The ELITE Fine-Art Paper is the flagship of Kodak papers. It has deep blacks, a rich tonal range, and a brilliant white. Thicker than a double-weight paper, it reduces remakes because it resists the dings, crinkles, and other physical damage suffered by less durable papers. POLYFIBER Paper is variable-contrast. It, too, features strong blacks and bright whites and a pleasing tonal rendition. Problem negatives can often be tamed by varying. the contrast on different areas of the print when using POLYFIBER Paper.

Resin-coated papers are a pleasure to use. Their fast fixing and washing times increase darkroom productivity, letting you make many prints per session. Experienced darkroom workers may notice differences between prints made on RC and fiber-base papers, but others won't notice. Whether you're using KODAK POLYPRINT Paper or KODAK POLYCONTRAST Rapid II RC Paper, give the E surface a try. The fine-grained texture of E-surface papers makes excellent display prints that reduce glare.

*Quality Enlarging with KODAK B/W Papers* (G-1), is an excellent guide to Kodak black-and-white printing papers and developers.

## Paper Developers

Selecting a paper developer is usually determined by the paper you wish to use and the image tone you wish to derive. In some cases, the developer can influence the contrast of the print. Generally, developers fall into two categories—those that produce warm image tones, and those that produce cold image tones. You choose an enlarging paper for print appearance and part of the choice is a developer that will work best with the paper.

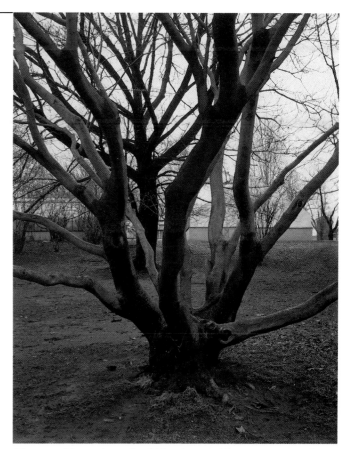

*Photographic products should be chosen with an eye to actual, not stated, performance. The prints in this column, for instance, were both made on a No. 2 grade paper, but from different manufacturers.*

Owen Butler

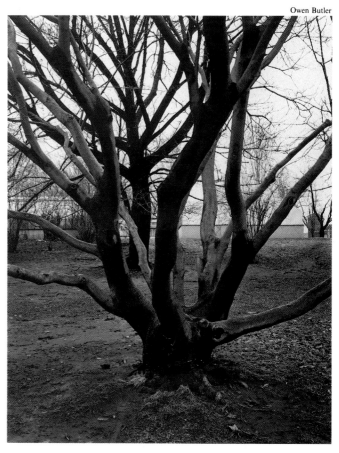

| KODAK Films | ISO (ASA/DIN°) Daylight / ISO (ASA/DIN°) Tungsten | Base | Retouching | Color Sensitivity | Graininess | Resolving Power | Enlarging | Applications and Characteristics | Sizes |
|---|---|---|---|---|---|---|---|---|---|
| Commercial Film 6127 | 50/18°<br>8/10° | A<br>ETB | N | B | VF | 100/40 | H | Copying continuous-tone originals; making B/W transparencies. Moderately high contrast. | Sheets |
| EKTAPAN 4162 (ESTAR Thick Base) | 100/21°<br>100/21° | ETB | B | P | F | 80/40 | M | Portraiture and close-up work with flash. Long toe, anti-halation protection. | Sheets, 3¹/₂″ and 70 mm rolls |
| High Speed Infrared 4143 (ESTAR Thick Base) | 80/20°<br>200/24° | ETB | N | VS, I | F | 80/32 | ML | Aerial, haze penetration, special effects in landscape, architectural, and commercial photography. Moderately high contrast; must be exposed through filters for correct infrared rendition. | Sheets and 35 mm magazines |
| KODALITH Ortho Film 2556, Type 3 (ESTAR Thick Base) and 6556, Type 3 | NA | E<br>A | N | B | NA | NA | NA | Graphic arts—line and half-tone reproduction; pictorial special-effects use for dramatic graphic results. Very-high contrast (only black and white tones); excellent for making high-contrast negatives or positives from continuous-tone originals in the darkroom. | Sheets and 35 mm long rolls |
| PANATOMIC-X and PANATOMIC-X Professional | 32/16°<br>32/16° | A | N | P | EF | 200/80 | VH | Use when great enlargement is required of small-format negatives; daylight and interiors with flash; reverse-process can provide B/W positive transparencies. Medium toe, low speed. | 35 mm mag, 35 and 70 mm rolls<br>120 rolls |
| PLUS-X Pan / PLUS-X Portrait 5068 / PLUS-X Pan Professional | 125/22°<br>125/22° | A | E | P | EF | 125/50 | H | Excellent for general daylight use. Short toe, long straight-line curves; PLUS-X Pan incorporates gray dye in the base for antihalation and to prevent edge fog; PLUS-X Professional and PLUS-X Portrait have clear bases with a retouching surface on the emulsion side. | 35 mm mag, 35 and 70 mm long rolls<br>35 and 70 mm long rolls<br>120 and 220 rolls |
| PLUS-X Pan Professional Film 2147 (ESTAR Base) and 4147 (ESTAR Thick Base) | 125/22°<br>125/22° | E<br>ETB | B | P | VF | 125/50 | H | Outstanding films for studio use. Long toe, excellent highlight separation, high sharpness; ESTAR Base resists damage and maintains dimensional stability. | 35, 46, and 70 mm long rolls<br>Sheets and 3¹/₂″ long rolls |
| Recording 2475 | 1000-3200/31°<br>1000-3200/31° | E-AH | N | P, XR | C | 63/25 | L | Existing-light photography in low light levels or when fast shutter speeds are required with small apertures; indoor sports, press photography, surveillance. Extended red sensitivity for use in tungsten light. | 35 mm magazines and Long rolls |
| ROYAL Pan 4141 (ESTAR Thick Base) | 400/27°<br>400/27° | ETB | B | P | F | 80/40 | M | Studio—commercial, industrial; wedding candids with flash when sheet film is required. Long toe—brilliant highlight separation. | Sheets and 3¹/₂″ Long rolls |
| SUPER-X Pan 4142 (ESTAR Thick Base) | 200/24°<br>200/24° | ETB | B | P | F | 100/40 | M | General-purpose: portrait, commercial, industrial; color separation negatives; B/W negatives from color transparencies. Long toe for excellent highlight separation; predicatable response in midtones from long straight-line section of curve. | Sheets |
| Technical Pan 2415, 4415 (ESTAR Thick Base) and 6415 (Acetate Base) | E.I. 25/15°<br>E.I. 25/15° | ETB, A | N | P, XR | EF | 400/125 | EH | Adaptable to a wide variety of different tasks depending on developing, from esoteric scientific work to breath-taking pictorial photography. Extraordinary grain characteristics and sharpness for pictorial situations that will require great enlargement. | 35 mm mag. and 4 x 5 sheets<br>120 rolls |
| T-MAX 100 Professional Film | 100/21°<br>100/21° | A | N | P | EF | 200/63 | H | Great for capturing fine-detailed subjects outdoors and in the studio. Uses T-GRAIN Emulsion to provide extremely high sharpness and extremely fine grain. Can also be used as a copy film. | 35 mm mag. and long rolls, 120 rolls, Sheets |
| T-MAX 400 Professional Film | 400/27°<br>400/27° | A | N | P | EF | 125/50 | H | Superior general-purpose film that uses T-GRAIN Emulsion. Extremely fine grain makes it good for commercial and portrait photography. Wide exposure latitude and speed capability up to EI 3200 make it a standout for photojournalism and law enforcement photography. | 35 mm mag. and long rolls, 120 rolls, Sheets |
| TRI-X Ortho 4163 (ESTAR Thick Base) | 320/26°<br>200/24° | ETB | B | B | F | 100/40 | ML | Press, industrial, commercial photography where absence of red is unimportant; portraits of men, elderly; character studies. Can be processed by inspection with KODAK Safelight Filter No. 2. | Sheets |
| TRI-X Pan | 400/27°<br>400/27° | A | N | P | F | 100/50 | H | General purpose—gives excellent tonal gradation in all types of lighting. Wide latitude, medium tone, responsive to contrast control with a variety of developers. | 120 rolls, 35 mm mag, and long rolls |
| TRI-X Pan Professional / TRI-X Pan Professional 4164 (ESTAR Thick Base) | 320/26°<br>320/26° | A, ETB | B | P | F | 100/32 | H | All types of lighting, especially good with low-flare tungsten and flash. Long toe, excellent gradation, brilliant highlights; good contrast control in development. | 120 and 220 rolls<br>4 x 5 film packs<br>Sheets, 3¹/₂″ long rolls |
| VERICHROME Pan | 125/22°<br>125/22° | A | N | P | EF | 100/50 | H | Highly adaptable, general-purpose film. Medium toe, wide latitude, excellent gradation. | 120 rolls |

**KEY FOR FILMS**

Base: A—ACETATE, E—ESTAR, ETB—ESTAR Thick Base, E-AH—Estar Anti-Halation
Retouching: B—Both sides, E—Emulsion Side, N—None
Color Sensitivity: B—Blue and green, P—Panchromatic, I—Infrared, VS—Visible Spectrum, XR—Extended Red
Graininess: C—Coarse, EF—Extremely Fine, F—Fine, VF—Very Fine, NA—Not Applicable

Resolving Power: Lines Per mm, High Contrast/Low Contrast
Enlarging Capability: EH—Extremely High, H—High, L—Low, M—Medium, ML—Medium Low, NA—Not Applicable, VH—Very High

| Paper Name | Contact Printing | Enlarging | Base Type | Surfaces | Weights | Contrast Grades | Stock Tint | Image Tint | Applications | Characteristics |
|---|---|---|---|---|---|---|---|---|---|---|
| AZO | X | | F | F E | SW DW SW DW | 1-5 2 2,3 2 | W | NB | High quality contact printing—fine arts, commercial, industrial | Rich quality for dignified presentation |
| EKTALURE | X | X | F | G | DW | 3 | Cr Cr Cr WW | Br-B B | Portrait enlarging, contact printing | Excellent for exhibition |
| EKTAMATIC SC | | X | F BC | F N A | SW DW SW LW | 1-4 VC | W | WB NB | Proofing, newspaper, medical, military | High-speed, variable contrast; stabilization or tray processing; fluorescent brighteners; incorporated developing agent. |
| ELITE Fine Art | | X | F | S | PW | 1-4 | W | NB | Fine art, commercial, industrial, portrait, or wherever premium quality is required. | High-speed; silver-rich emulsion for deep blacks, brightener for brilliant whites; speed-matched contrast grades; heavy, fiber base. |
| KODABROME II RC | | X | RC | F, E, N, | MW | 1-5 | W | WB | General enlarging | Fluorescent brighteners, incorporated developer, tray or machine processing. |
| KODABROMIDE | | X | F | F E | SW, DW SW, DW | 1-5 2-4 | W | NB | General-purpose enlarging | High speed |
| Mural | | X | F | R | SW | 2,3 | Cr | WB | Photo-mural and other large work | Extra strength and abrasion resistance to withstand folding. |
| PANALURE | | X | F | F | SW | — | W | WB | B/W enlargements from color negatives; commerical, school, portrait | Panchromatic for proper tonal rendition with color negatives. |
| PANALURE II RC PANALURE II Repro RC | | X | RC | F | MW | — | W | WB | B/W enlargements from color negatives; general, enlarging, school, commercial portrait photography | Panchromatic for proper tonal rendition for color negatives; incorporated brighteners and developer; lower contrast grade of the Repro paper aimed for photomechanical production. |
| POLYCONTRAST Rapid II RC | | X | RC | F, N, E | MW | 1-4 VC | W | WB | General enlarging, commercial, aerial, mapping, industrial, advertising display, police, school | High speed, variable contrast, fluorescent brightener, incorporated developer. |
| POLYFIBER | | X | F | F N G A | SW, DW DW LW | 1-4 VC | W Cr W | NB | General enlarging | Brightener in base for cleaner whites; wide development range; rich, deep blacks |
| POLYPRINT RC | | X | RC | F, N, E | MW | 1-4 VC | W | C NB | General enlarging, press, commercial, school | Wide development latitude, variable contrast, brightener incorporated |

**KEY FOR PAPERS**

Base Type: F—Fiber, BC—Baryta Coated, RC—Resin Coated
Surfaces: Standard KODAK Paper Surface Descriptions
Weights: LW—Light Weight, SW—Single Weight, MW—Medium Weight; DW—Double Weight, PW—Premium Weight
Contrast Grades: Numbers are Standard Kodak Contrast Grading, VC—Variable Contrast

Stock Tint: Cr—Cream, W—White, WW—Warm White
Image Tint: B—Black, Bl-B—Blue-Black, Br-B—Brown-Black, NB—Neutral Black, WB—Warm Black, RP—Red-Purple, C NB—Cool Neutral Black

| KODAK Paper Developers | Property/Use | Liquid | Powder | Package |
|---|---|---|---|---|
| KODAK DEKTOL Developer | High-capacity developer that produces neutral and cold-tone images on cold-tone papers. Clean working. | — | X | makes 1 qt., 1/2 1, and 5 gals. |
| KODAK EKTAFLO Developer, Type 1 | Similar to DEKTOL—neutral or cold tones on Kodak cold-tone papers. For use with with EKTAFLO Stop Bath and Fixer. | X | — | 1 gal. of conc. sol. |
| KODAK EKTAFLO Developer, Type 2 | Produces warm, rich tones with warm-tone papers. For use with EKTAFLO Stop Bath and Fixer. | X | — | 1 gal. of conc. sol. |
| KODAK SELECTOL Developer | Long-life developer designed for development of warm-tone papers. Clean working, high capacity—consistent activity throughout solution life. Lowers print contrast. | — | X | makes 1/2, 1, and 5 gals. of stock sol. |
| KODAK SELECTOL-SOFT Developer | Similar to SELECTOL Developer except produces softer contrast for improved shadow detail without loss in tonal scale. | — | X | makes 1 gal. of stock sol. |
| KODAK EKTONOL Developer | Non-carbonate developer for warm-tone papers that minimizes stain on prints to be toned. Development rate remains nearly constant throughout working life for consistent image tone. | — | X | makes 1 and 5 gals. |
| HOBBY-PAC™ | Concentrated liquid in foil packet. Gives results similar to DEKTOL Developer. Comes with packets of stop bath and fixer. | X | — | Makes 1 qt. |

# Photographic options

*Black-and-white photography can be an extremely expressive medium because it offers a wealth of opportunity to influence the final image. At various stages of the process you can make choices that have subtle or pronounced effects on the way the picture looks or even on how long it lasts. Major options include film format, the specific film, exposure manipulation and variation, filtration, darkroom manipulation in film processing and printing, print finishing and presentation of the final image.*

## FILMS

### Film Format

Although modern black-and-white films are capable of yielding excellent quality even when greatly enlarged, it is still true that the bigger the negative, the better the print quality, all other factors being equal (which they often aren't). Large negatives, however, imply large cameras. If you wish to make detailed still-life or architectural studies, a large sheet-film camera would be a sensible choice.

On the other hand, if you wish to make portraits quickly and easily to preserve a spontaneous feeling, you might prefer a faster-handling roll-film camera that produces medium-format negatives. And if you like to photograph sports or other action subjects, you will probably happily trade negative size to gain the rapid-fire advantages of lightweight, versatile 35 mm equipment. Clearly, it isn't always practical to make big negatives. Nonetheless, when you expect to make extremely large prints, try to use the largest film possible for convenient camera work. And try to use the finest grained film, such as KODAK Technical Pan Film or T-MAX 100 Film, both available in 120, 35 mm and sheet sizes.

### Film Type

Different black-and-white negative materials, besides having obvious differences in film speed, have other distinct characteristics that may make them suited to specific pictorial purposes. When circumstances permit, consider film contrast, sharpness, and graininess in relation to the way you wish to render the subject and the size to which you will enlarge the image. Although most photographers have a favorite film they use almost reflexively, there are times when a less familiar film may be more appropriate to the task at hand. Several Kodak monochrome films of unusual interest and distinctive characteristics are highlighted later in this section.

In orchestrating the photographic options, you are somewhat like a composer expanding a theme for symphonic expresssion. To create visual harmony rather than dissonance, you must know what options you have and the effects they produce. And just as a composer "hears" the effects produced by different instruments, you, as a photographer, must have a clear vision in your mind's eye of the potential of your tools. The most important single factor in pro-

*A reception, a hit, a loose ball. It all happens so fast that only the anticipation of an experienced photojournalist using a high-speed film can catch it. The high film speeds possible with T-MAX 400 Professional Film enable you to use action-stopping shutter speeds under almost any lighting conditions. You can rate T-MAX 400 Professional Film at EI 400 or 800 and develop it normally, or you can push it all the way up to EI 3200 if you develop it in T-MAX Developer.*

*The minute detail in this image was sharply recorded on KODAK Technical Pan Film 2415, 135-size, developed in KODAK Technidol LC Developer.*

ducing an excellent black-and-white photograph is knowing how all the tools at your disposal will affect the final print. Then you can make a series of informed choices that will lead to the desired image.

The following pages present a variety of materials and techniques to help you extend your expression beyond fundamental black-and-white practices. First, however, consider some of the basic factors that help determine the final image.

Kevin Higley

Sam Dover

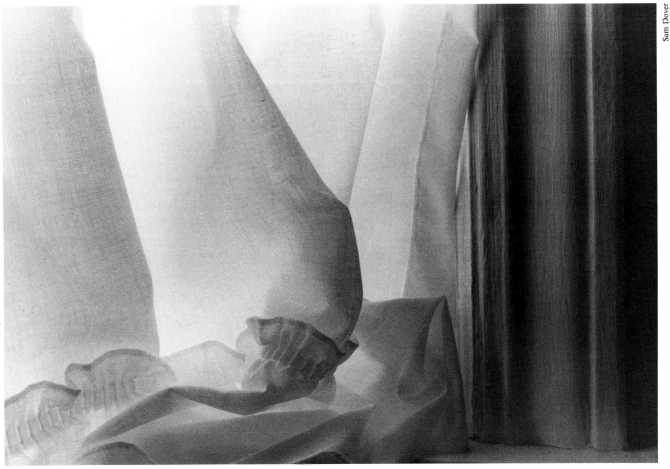

## INFRARED FILMS

Although primarily associated with scientific and technical applications, infrared-sensitive black-and-white films can be used successfully in pictorial photography to produce striking images. Unlike conventional black-and-white materials, infrared-sensitive films respond to invisible infrared radiation as well as to visible light. Since many subjects absorb or reflect infrared radiation quite differently from the way they absorb or reflect visible wave-lengths, photographs made on infrared films look distinctively different from conventional black-and-white renderings.

KODAK High Speed Infrared Film is available in three basic versions: Type 2481 (ESTAR Base) in 36-exposure 35 mm magazines, Type 2481 (ESTAR Base) in 35 mm X 150-foot rolls, and Type 4143 (ESTAR Thick Base) in 4 X 5-inch sheets.

### Infrared Rendition

Pictures made outdoors on black-and-white infrared film tend to show excellent haze penetration, revealing distant features with greater clarity than could otherwise be obtained. Live green foliage and grass record very light because they reflect infrared efficiently. Blue sky, which is low in infrared radiation, records much darker than it would on general-purpose black-and-white materials. Additionally, the typically diffuse, grainy treatment seems to heighten the effect—real and apparent—of seeing in a new dimension. Infrared photographs can depict the real world with surreal and fantastic overtones.

### Handling Infrared Films

KODAK High Speed Infrared Films must be loaded in total darkness or in an infrared-opaque changing bag. This applies to loading 35 mm cameras with film contained in 35 mm magazines as well as to loading sheet film into film holders. Film holders should be absolutely lighttight, and when pulling the slide, obscure your camera with a dark cloth as an extra precaution.

### Filters for Infrared Photography

Because KODAK High Speed Infrared Films are sensitive to visible light as well as to infrared radiation, they must be exposed through filters that pass infrared freely while excluding some or all visible wavelengths. As you allow less visible light to affect the film, the infrared effects will be more obvious. KODAK WRATTEN Filters recommended for black-and-white infrared photography include: No. 25, No. 29, No. 70, No. 89B, No. 87, No. 87C and No. 88A. The first three filters are increasingly deeper red, but permit viewing and focusing in bright light when mounted on the lens of an SLR or view camera. The rest are visibly opaque and prevent through-the-lens viewing.

### Infrared Exposure

The amount of infrared radiation bathing a scene does not necessarily correlate with the visible illumination, so conventional exposure meters do not provide reliable guidance for exposures that will be made mostly or entirely infrared. As starting points for experimentation, use the film-speed settings recommended in the accompanying table, bracket extensively, and take notes for future reference. When using a through-the-lens light meter, make the reading before mounting the filter over the lens, then ignore the meter readout after attaching the filter. Automatic-exposure cameras should be switched to the manual mode. Practical experience indicates that satisfactory exposures may be made outdoors in bright sunlight with a No. 25 filter using camera settings of 1/125 second at f/11 for distant scenes and 1/30 second at f/11 for nearer subjects such as individual buildings and monuments.

### Focusing for Infrared

Camera lenses do not focus infrared radiation in the same plane as visible wavelengths. Many lenses for 35 mm and medium-format cameras have infrared focusing indices (usually colored red) to help establish best focus when exposing infrared film. First, focus the camera normally. Note the distance opposite the normal focusing index. Then turn the focusing collar to bring that distance into alignment with the infrared focusing index. This procedure corrects the focus setting.

If your lenses do not have an infrared focusing mark, you can still achieve reasonable accuracy by focusing on the near side of the subject. Set the lens to a relatively small aperture to help cover minor discrepancies with depth of field.

For more detailed information about KODAK High Speed Infrared Films and how to use them, consult the following Kodak books. *Applied Infrared Photography* (M-28) and *KODAK Professional Black-and-White Films* (F-5).

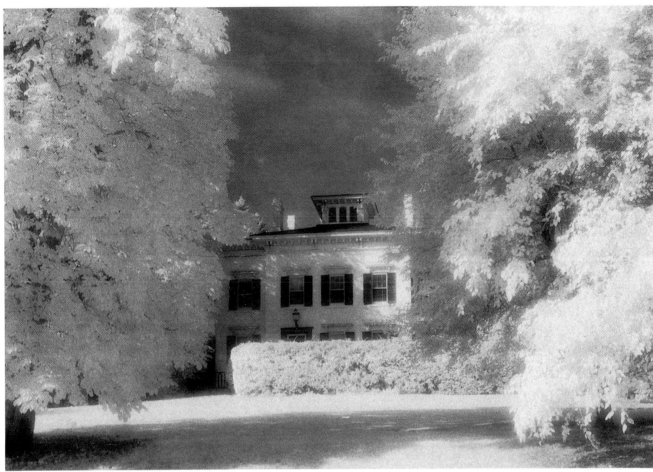

Martin L. Taylor

*Infrared rendition of architecture, foliage, or even portraits can provide an exciting extra dimension in monochrome photography. Because infrared radiation intensity varies without regard to visible light intensity in the scene, it is a good idea to bracket your exposures. Also, focusing as generously as possible with the smallest aperture you can manage will help your picture sharpness.*

### Meter Settings*

| KODAK WRATTEN Filters | Illumination | |
| --- | --- | --- |
| | Daylight | Tungsten |
| No Filter | 80 | 200 |
| No. 25, 29, 70, or 89B | 50 | 125 |
| No. 87 or 88A | 25 | 64 |
| No. 87C | 10 | 25 |

*Based on suggested development time in KODAK Developer D-76.

75

Tom Beelmann

## KODAK TECHNICAL PAN FILM

A remarkably versatile film, KODAK Technical Pan Film may be exposed and developed to yield negatives displaying contrast levels from extremely high to normal. In its high-contrast modes, you can use it for copying text or line art, for a host of scientific or technical purposes, or for making boldly graphic pictorial interpretations. In its lower-contrast mode, at a film-speed setting of ISO 25 in conjunction with development in KODAK TECHNIDOL Developer, Technical Pan Film offers continuous-tone negatives of breathtaking sharpness and resolution that may be enlarged to extreme degrees before showing noticeable traces of film grain. Technical Pan Film is available in all popular roll and sheet film sizes.

Prints made from 135- and 120-size negatives compare favorably with prints made from 4 x 5-inch negatives of other films. For comprehensive data about this film and its applications, see *KODAK Technical Pan Film,* KODAK Publication P-255.

### Hints for Optimum Quality

This film's extraordinary ability to reveal fine subject detail is a two-edged

*KODAK Technical Pan Film performs to extraordinary standards when developed according to instructions in KODAK TECHNIDOL Developer. Sharpness, grain, and resolution stretch the imagination, and permit some degree of large-format results with the convenience of small-format equipment. The image of the rabbit, above, was enlarged 8X (and cropped) from the original negative. The small view of the rabbit's eye at right represents a 30X enlargement.*

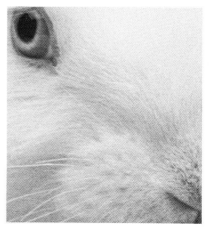

sword—it also reveals deficiencies in photographic technique. Focus carefully on the most important subject plane. Select an aperture that provides adequate depth of field and at which the lens performs well optically. Use a tripod or other firm camera support with a cable release when possible. Make sure lens surfaces are clean. Determine exposure precisely, carefully avoiding overexposure. Process the film exactly according to instructions, giving special attention to the critical immersion and agitation procedures.

Because Technical Pan Film is somewhat more sensitive to red than conventional black-and-white films, it records reddish subject tones slightly lighter than usual. For most pictorial purposes this is neither noticeable nor objectionable. In landscape photographs, haze is reduced. Be aware, though, that skin tones are rendered slightly lighter than you might expect in direct daylight and tungsten illumination. Whether or not you like the effect is personal preference.

76

*The fast action of hockey and the dim lighting of an indoor arena mandate a fast film. Here T-MAX 400 Professional Film was rated at EI 800 and developed in T-MAX Developer. Photojournalists often assign a specific film-speed number to arenas, stadiums, and other artificially lighted locations that they repeatedly work in. They choose a number that will give them action-stopping shutter speeds and may use only one shutter speed and aperture for their work. The baseball stadium might be EI 800, the basketball arena EI 1600, and city hall might be EI 3200.*

Kevin Higley

## VERY HIGH-SPEED FILM

Films rated at ISO 800 or faster are considered very high-speed films suitable for journalistic, sports, surveillance or industrial photography in low light levels or when fast shutter speeds and small lens apertures are required simultaneously. Films in this category exhibit more graininess and slightly softer images in terms of sharpness and contrast than usually result with slower films.

### KODAK T-MAX 400 Professional Film

This film is ideal for photojournalism, sports, and existing-light photography. Its wide-exposure latitude enables you to rate it at EI 800 and still develop it normally. You can push this film all the way to EI 3200 if you develop it in T-MAX Developer.

The high speed and extremely fine grain of T-MAX 400 Film make it a versatile film that you can use to photograph fine-art landscapes in the afternoon and football games at night—all on the same roll.

### KODAK Recording Film 2475 (ESTAR-AH Base)

This film, available in 135-size, 36-exposure magazines and 135-size long rolls, features extended red sensitivity for use in low levels of tungsten light. Effective film speeds range from 1000 for scenes of average contrast (4-stop brightness difference) to 4000 (with extended development) for scenes of

extremely low contrast (3-stop brightness difference). It is compatible with KODAK DK-50 and HC-110 Developers. The somewhat soft, gritty-textured look characteristic of this film lends itself to delicate, high-key portraiture as well as to somber, brooding, low-key moods.

### Special Considerations

Because these films are extremely light-sensitive, load your camera in subdued light or shade. Check your darkroom and, if applicable, your sheet-film holders for light leaks. Use fresh developer for best results. The

extended red sensitivity of KODAK Recording Film 2475 (ESTAR-AH Base) may make skin tones record lighter than usual. It also responds somewhat differently with certain filters and may require use of different filter factors, so check the film data first. Compose images tightly to reduce the enlargement necessary for after-the-fact cropping unless you desire a noticeable grain effect. Excessive enlargement of these films can exaggerate graininess more than it does with slower-speed films. For more detailed data, see *KODAK Professional Black-and-White Films* (F-5).

*KODAK Recording Film 2475, ISO 1000, under a single 60-watt bulb.*    Tom Beelmann

77

Martin L. Taylor

John Menihan

*Negative made on SUPER-XX Pan Film and printed on ELITE Fine-Art Paper.*

## MAKING BLACK-AND-WHITE PRINTS FROM COLOR NEGATIVES AND TRANSPARENCIES

Making satisfactory black-and-white prints from color negatives and transparencies is easier than you might think. The procedures are logical extensions of conventional black-and-white photography and darkroom work that require no major special equipment.

### Black-and-White Prints from Color Negatives

You may know from experience that you can produce a recognizable image by printing from a color negative onto conventional black-and-white enlarging paper. If you've tried this, you also know that some tones in the print are nearly always lighter or darker than they ought to be. This happens because the enlarging paper is sensitive primarily to blue or blue and green light and is relatively insensitive to other colors that may figure prominently in a color negative.

To obtain a good black-and-white print from a color negative, use a printing paper that, like general-purpose black-and-white film, can render a wide variety of colors in appropriate shades of gray. Kodak manufactures three such enlarging papers: KODAK PANALURE Paper, KODAK PANALURE II RC Paper, and KODAK PANALURE II Repro RC Paper. The first is fiber-based, the latter two are resin-coated. PANALURE II Repro Paper is approximately one grade lower in contrast than PANALURE II and is especially well suited for photomechanical reproduction.

Because these papers are sensitive to more wavelengths of light than ordinary papers, you'll need a different safelight. Use a KODAK 13 Safelight Filter (amber) with a 15-watt bulb no closer to the paper than 4 feet, or work in total darkness until the paper has been fixed for a minute. Expose and process KODAK PANALURE Papers as though they were ordinary black-and-white enlarging papers. You can alter print contrast and tonal relationships by using (beneath the enlarging lens) the same colored filters you would use if photographing the original scene on black-and-white film.

### Black-and-White Prints from Color Transparencies

Making a good black-and-white print from a color transparency is a two-stage process. The first step is to make a black-and-white copy negative of the slide. The second is to make the print from the copy negative. The quality of the print will depend on the quality of the copy negative.

If your enlarger accepts 4 x 5-inch negatives, make enlarged copy negatives on KODAK SUPER-XX Pan Film 4142 in that size. You can use your enlarger to project the transparency onto the sheet of copy film. If you cannot use a large negative, make a same-size copy of the transparency in-camera on T-MAX 100 Film, exposed and developed for reduced contrast. Do it with a ready-made or improvised slide copier. Whichever method you use, copy the transparency through the base side rather than emulsion-to-emulsion. If you forget, you'll find yourself with a reversed copy negative that has to be printed through its base to make a right-way-round print.

Making the copy negative is analogous to photographing a similar full-color scene on black-and-white film. You can use colored filters during the copy exposure to selectively lighten or darken the gray-tone rendition of various colors in the slide. Experiment with exposure and development for best results.

*The quiet simplicity of this carefully arranged composition is aided by the use of Technical Pan Film, exposed at ISO 200 and developed for three minutes in straight DEKTOL Developer. The resulting contrast eliminated extraneous highlight information in the windows and foreground.*

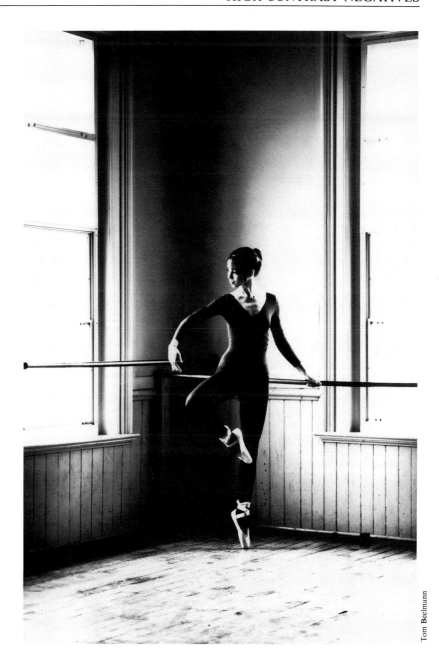

Tom Beelmann

## HIGH-CONTRAST NEGATIVES

Negatives of higher contrast than normal can be used to make prints of great graphic impact, characterized by brilliant whites, intense blacks and few or no intermediate shades of gray. There are two basic approaches you can use, depending on the degree of negative contrast you want.

### Moderately High-Contrast Negatives

If the print contrast you want can be achieved with a negative of moderately high contrast, or if you expect to use the camera original as a point of departure for making much-higher-contrast copy negatives (see pages 79-81), you can start with a general-purpose black-and-white film. Simply underexpose it by about one stop and overdevelop it by 50 to 100 percent in a fairly active developer such as full-strength KODAK D-76 Developer or KODAK Developer HC-110 in a high-strength dilution. Even greater contrast may be obtained by developing the film in an undiluted stock solution of KODAK DEKTOL Developer (for prints). Such forced development tends to increase graininess and decrease sharpness, so use a very sharp, fine-grain film if you expect to make extreme enlargements. Specific exposure and development data are best determined by experimentation.

### Very High-Contrast Negatives

To maximize contrast in the camera, take the picture on film stock of inherently high contrast. Although Kodak manufactures a variety of extremely high-contrast materials for graphic arts and other specialized applications, a widely available alternative also capable of producing exquisitely sharp continuous-tone negatives is KODAK Technical Pan Film 2415/6415. (See page 76.) For very high-contrast results, use a meter setting of ISO 200 and develop the film in KODAK DEKTOL Developer for 3 minutes at 68°F (20°C). Other developers that produce extremely high contrast with this film are KODAK Developers D-19 and HC-110.

*The original, dull scene shown below received an infusion of interest when graphically transformed with KODALITH Materials. Below, note the two prints at left and the intermediate film positive and negative at right.*

## MAXIMUM-CONTRAST PRINTING

Even the highest-contrast grades of enlarging paper cannot produce prints completely free of intermediate shades of gray when you enlarge directly from a continuous-tone negative. To make a print that consists solely of clean whites and intense blacks requires a negative of much higher contrast than normal. You can attain the boldly graphic results you want by contact printing the original negative on an extremely high-contrast film, recontacting the high-contrast positive with another sheet of high-contrast film, then making the final print from the resulting extremely high-contrast negative. This multi-stage procedure is actually easier to do than to describe.

Tom Beelmann

80

*Careful spotting of the final negative from KODALITH Film will avoid the tedious task of spotting subsequent prints.*

Tom Beelmann

## Materials You'll Need

The only extra things you'll need are extremely high-contrast film, suitable developer, an appropriate safelight filter, and a small quantity of retouching opaque. One of the most convinient films to use is KODALITH Ortho Film 6556, Type 3, which is available through photo dealers and graphic arts suppliers in sheet sizes from 4 x 5 inches through 11 x 14 inches. The film is not sensitive to red light and can be handled under a safelight equipped with a KODAK 1A Safelight Filter (light red) and a 15-watt bulb no closer than 4 feet. Develop the film in a tray, like a print, using KODALITH Developer. KODAK Opaque, for covering pinholes in high-density film areas or painting out unwanted detail, is available in 1-ounce jars. It comes in red and black versions—either will do.

## How To Do It

The best way is to enlarge the image from your original negative onto a sheet of KODALITH Film the same size you want the finished image. Contact printing subsequent stages will lower your retouching effort. You can also get good results by making smaller KODALITH Film negatives and then enlarging them. KODAK EKTAGRAPHIC HC Slide Film is essentially a KODALITH Film but is available in 36-exposure 135 magazines. The amount of exposure in making the KODALITH Film negative determines the proportion of black to white in the final print. The longer the exposure, the more intermediate tones will be forced into black. The shorter the exposure, the more intermediate tones will be shifted to white. When you process this first sheet of KODALITH you will have a very high-contrast positive on film. If it shows the white/black balance you want, wash and dry it. If not, make another at a corrected exposure time.

Inspect the dry positive KODALITH Film on a lightbox. Use a magnifying glass to look for clear pinholes in areas that should be uniformly dense. Cover them with tiny dabs of opaque. You can apply it to either the emulsion or base side of the film positive. If you retouch the emulsion side, don't build up heavy layers of opaque. Apply just enough to cover the spot, and no more. You can use the opaque to paint out larger areas of the image, too. Whatever you opaque on the positive will be black in the final print.

Place the positive KODALITH Film in a contact-printing frame emulsion-to-emulsion with a sheet of KODALITH Film and expose it with your enlarger. Process the exposed film, and you'll have an extremely high-contrast negative. When it is dry, examine it on a lightbox. Opaque any pinholes you find in dense areas. Areas you opaque on the negative will print white. If you see any dense spots in what should be uniformly clear areas, bleach them with KODAK Farmer's Reducer. If there are few such specks, it may be easier simply to spot the print later.

At this point you can make the final print by contact-printing the extremely high-contrast KODALITH negative emulsion-to-emulsion with a sheet of enlarging or contact paper. The contrast grade or filter doesn't really matter because the KODALITH Film negative will be so contrasty that only blacks and whites form the image. Any minor areas of gray tone or depressed highlights, can be removed from the print with local applications of KODAK Farmer's Reducer or a solution of potassium ferricyanide.

## Additional Hints

Clean the negatives, film positives, and glass in your contact frame meticulously because high-contrast materials record even tiny dust spots with painful clarity. Handle sheets of KODALITH Film only by the edges to avoid leaving fingerprints for posterity. If the first negative on KODALITH Film lacks sufficient contrast for your purposes, use it to make a second-generation positive on KODALITH Film from which you can produce an even contrastier KODALITH negative.

## FILTERS AND LENS ATTACHMENTS

Filters allow you to fine-tune or deliberately exaggerate the way colors are rendered as various shades of gray. You can emphasize or repress different parts of a scene and increase or decrease overall image contrast. Lens attachments that mount like filters allow you to alter the look of a picture easily, when you wish to interpret rather than mirror the subject. Although the use of lens attachments is familiar in color photography, there is no practical reason why such devices can't be applied to monochrome imagery.

### Fine-Tuning Rendition

General-purpose black-and-white films are sensitized to render scene colors as appropriately light or dark shades of gray. Individual gray tones and tonal relationships within the print resemble the visual impressions created by the scene. Some minor "mistranslation" normally occurs, but is rarely noticeable or objectionable in nontechnical applications. You can preview the way a general-use black-and-white film will render a daylighted scene by looking through a KODAK WRATTEN Gelatin No. 90 Filter, which is used for monotone viewing. This dark grayish-amber filter provides a visual approximation of the gray-tone rendition of the subject colors you will encounter later in your darkroom.

Most general-purpose black-and-white films are more sensitive to blue and ultraviolet than to red or green light. The human eye, on the other hand, is less sensitive to blue than to red or green. To bring tonal relationships on film into closer correspondence with direct visual impresssions, use a No. 8 yellow filter when photographing outdoor scenes in daylight. A No. 11 yellowish-green filter provides analogous correction of film response when photographing tungsten-lighted subjects.

### Contrast Control

You can use filters to lighten or darken various colors in a scene selectively, thus altering tonal relationships and overall contrast. The basic rules are: Use a filter similar in color to colors you wish to render lighter, or use a filter complementary in color to subject colors you wish to darken. For example, a red ball on a green lawn presents a distinctively sharp color contrast. In black-and-white, the two colors may be rendered as similar shades of gray. To restore tonal separation, you might photograph through a red filter to lighten the ball, which is of a similar color, and to darken the green lawn, which is of complementary color. Conversely, you could photograph through a green filter if you wished to show a dark ball on a light-toned field.

### Blue Skies

Again, because most black-and-white films are highly sensitive to blue, blue skies often record lighter than they look. To render the sky darker so that white clouds or ground features stand out better, use a No. 8 yellow, No. 15 deep yellow, or No. 25 red filter respectively for increased effectiveness. No. 58 and No. 61 green filters also darken the sky.

### Exposure Through Filters

Colored filters work their magic by preventing light of complementary colors from reaching the film. If your camera has a through-the-lens light meter, consult the camera manual to see if the meter reads correctly through filters. Many do. If not, or if you use a separate, handheld exposure meter, you will have to compensate for a filter's light-blocking effect when determining exposure.

The amount of exposure increase required for a given filter's light absorption is expressed as a numerical filter factor. Most filters have different factors for daylight and tungsten illumination, as well as for differently sensitized films. Filter factors are published by filter and film manufacturers and are sometimes engraved or embossed on the mounting rings of screw-in and series-size filters. The filter factor indicates by how much to multiply the basic exposure. A factor of 2, for example, indicates that you would have to double the metered exposure, increasing it by one full stop. A filter factor of 4 would require quadrupling the metered exposure, increasing it by 2 full stops. You can also divide the film ISO by the filter factor. Use the new ISO for your exposure calculation with a filter.

Published filter factors should be considered approximate guides rather than inflexible values. You may find that with a certain filter you obtain the results you prefer by giving more or less exposure than a published factor suggests. If that happens, by all means continue to use your personal filter factor.

*The filter comparison series at right shows the effect on colors, foliage, sky, and clouds of different commonly used filters.*

*KODAK EKTACHROME 100 Film (Daylight)*

*No Filter*

*No. 8 Filter (yellow)*

*No. 15 Filter (deep yellow)*

*No. 25 Filter (red)*

*No. 47 Filter (blue)*

*No. 58 Filter (green)*

Tom Beelmann

*Polarizing filters cut relections from non-metallic sources, whether tiny droplets of water in haze or mirror-like reflections in glass. It's possible to preview the effect by turning the polarizing filter in its mount. Bottom photo: without filter; top photo: with filter.*

### Polarizers

A polarizing screen, or polarizer, mounts over the lens like a filter, but generally can be rotated in a free-turning ring while still attached to the lens. Although most often used in color photography, polarizers are also useful with black-and-white films for removing unwanted specular reflections from non-metallic subjects. You can use a polarizer to darken a blue sky, darken bodies of water, see through shallow water for a better view of subsurface detail, and reduce or eliminate annoying surface reflections from windows. You can preview the effect by rotating the polarizer while looking through it, selecting the precise degree of reflection suppression that suits you.

Polarizing screens have a suggested filter factor of about 2.5, or 1 1/3 stops, regardless of the filter position and apparent effectiveness. Bracket exposure by half-stops until you develop a feel for working with a polarizer. For that matter, bracket exposure with any filter when conditions permit. Your taste is the ultimate critic. Filter factors and exposure suggestions are merely guidelines to help you start. Polarizers may be used simultaneously with other filters to obtain very strong overall effects. Multiply both filter factors to determine a cumulative factor.

Tom Beelmann

*Lens attachments can sometimes augment an effect or enhance a mood. A diffusion filter was used to make this photo.*

## Fog Filters and Diffusers

Fog filters and diffusers produce romantic photographs reminiscent of those made with the soft, low-contrast lenses popular with the Pictorialists of the late nineteenth century. The clear, filter-like discs or squares of optical glass or plastic feature molded, etched, or scribed patterns that disrupt light transmission enough to soften the image. They are available in strengths that produce effects ranging from subtly delicate to strongly blurred. They are useful for portraiture and for evoking dreamy, misty moods. Most require little or no exposure modification. Some diffusers produce different degrees of softening depending on the lens aperture, with the greatest diffusion occurring at the widest opening and little or no softening evident at very small apertures. If you use an SLR with a preview system, check the image at the actual shooting aperture.

Most image-softening devices lower image contrast to some extent. If you wish to compensate for contrast loss, increase the film development time slightly or print on a harder grade of paper or with a higher-number selective-contrast filter. Some diffusers and fog filters can also be used effectively beneath an enlarger lens. Diffusion during printing tends to produce a darker, heavier effect than in-camera diffusion because the former technique spreads shadows into highlight areas while the latter spreads highlights into shadows.

*Tom Beelmann*

## PROCESSING AND STORAGE OF NEGATIVES AND PRINTS FOR LONG-TERM IMAGE STABILITY

Assuming favorable storage conditions, properly processed black-and-white negatives and prints can easily outlast the people who make them. The existence today of black-and-white photographs in excellent condition made during the early years of photography testifies to the potential longevity of silver images. Although resin-coated (RC) papers are now generally acknowledged as capable of having a long life, our long-term experience with the properties of fiber-base papers makes them the recommended choice of materials when long-term keeping is the main goal.

If you closely follow the manufacturer's processing recommendations, you should produce negatives and

*Washing is an important step because it eliminates fixer from your prints. Also, careful handling of prints in the wash usually gives you a higher percentage of keepers.*

prints with long-term keeping characteristics. However, we'll briefly discuss the areas of processing and storage that are important for long-term keeping of your negatives and prints. If long-term keeping of images is extremely important to you, you need more information. Refer to the KODAK Publication *Conservation of Photographs* (F-40). It discusses in depth the many procedures and facts you need to know to preserve photographic images.

### FIXING TIPS

Use fresh fixer and do not fix longer than the recommended time. Excessive fixing makes it difficult if not impossible to properly wash hypo out of fiber-base prints. If processing sheet negatives or prints in a tray, do not fix too many pieces simultaneously or they may stick to each other and prevent proper fixing. Agitate thoroughly by interleaving during such batch processing. Be sure not to exhaust the fixing bath.

Although one fresh fixing bath is fine, the two-bath fixing method is the most efficient method for fiber-base prints. Use the following procedure for the two-bath method.

1. Mix two fresh fixing baths and place them side by side.
2. Fix the prints for 3 to 5 minutes in each bath. Do not turn on room lights until prints are in the second bath.
3. Discard the first bath when fifty 8 x 10-inch prints per quart of solution have been fixed.
4. Move the second bath over to become the first bath.
5. Mix a fresh fixing bath and place it beside the first one.
6. Repeat the above cycle four times.
7. After five cycles, mix fresh solution for both baths.
8. If five cycles are not used in one week, mix fresh solution for each bath at the beginning of the second week.

### WASH THOROUGHLY

Wash negatives and prints in water flowing rapidly enough to provide at least one complete change of water in the vessel every 5 minutes. The wash temperature should be 68 to 74°F (18 to 24°C). Avoid temperatures below 60°F (18°C), as residual chemicals become difficult to wash out. If batch washing 8 x 10-inch or larger prints, interleave them regularly so the entire print area is well washed.

### WASHING AIDS

KODAK Hypo Eliminator should never be used with film. It should be used with prints only if staining has previously resulted when prints were toned.

Although hypo can be sufficiently removed just by washing with water,

KODAK Hypo Clearing Agent can be used when shortened wash times or water conservation is required. After fixing films, rinse them in water for 30 seconds, then bathe in a solution of Hypo Clearing Agent for 2 minutes with agitation. Then wash in water for 5 minutes. With fiber-base papers, rinse in water for 1 minute after fixing. Treat single-weight papers in the Hypo Clearing Agent for 2 minutes, double-weight papers for 3 minutes. Wash the single-weight papers in water for at least 10 minutes, the double-weight papers for at least 20 minutes. Prints can go directly from fixer into the hypo clearing bath but life of the bath will be significantly shortened.

If intended for long-term keeping, prints treated in Hypo Eliminator must be toned.

## TONING

Despite all of the recommended techniques to this point, the silver image is subject to deterioration from numerous external contaminants and factors. Many of these adverse effects can be substantially reduced by treatment with toners, such as KODAK Rapid Selenium Toner, KODAK POLY-TONER, KODAK Sepia Toner, or KODAK Brown Toner. For optimum stability no one dilution is equally applicable to all films and prints. Until data for specific products becomes available, we suggest immersing film or prints for 3 minutes in a 1:20 dilution of the selenium toner (1 part selenium toner, 20 parts water). For most types of paper that dilution will give little or no change in print color. It has the added advantage of deepening the blacks in a print.

## DRYING

Utmost cleanliness is crucial to avoid chemical contamination. Film should be dried in a dust-free cabinet or room. Fiber-base prints can be dried on Fiberglas® screens, between Kodak photographic blotters (replace after one use), or on a heat drum. The screens must be kept clean of residual chemicals from previous prints; the cloth belt from a dryer should periodically be washed in hot water and a mild detergent. Resin-coated prints can be hung by a corner on a line to dry or placed on a dust-free table or clean towels.

## MOUNTING AND DISPLAYING PRINTS

Like any photographer proud of his work, you'll undoubtedly be mounting and displaying some of your prints. The first guideline is to dry-mount the print on an acid-free, archival quality mounting board. The dry-mounting tissue will help protect the print from impurities migrating from the mounting board. Do not use rubber cement, contact cement, starch paste or animal glue. Use an overmat to protect the print from abrasion.

When hanging prints, provide only enough light for comfortable viewing. Especially avoid light sources rich in ultraviolet light, such as direct daylight and fluorescent lights. Tungsten illumination is preferred. Hang in an area where the temperature does not fluctuate by more than a few degrees over several hours.

## HANDLING NEGATIVES AND PRINTS

Handling prints and negatives makes everyone nervous--especially the photographer. Keep handling to a minimum. Wear cotton gloves and take care that negatives or prints don't gouge each other. When stored, make sure that negatives are stored separately so that corners and edges won't cut other negatives. Interleave prints with material suitable for long-term storage. Avoid handling processed photos in your darkroom. No matter how clean, it is a likely source of contamination.

## STORAGE

Impeccable processing, washing, and drying procedures are the first steps toward prolonging the life of your valuable photographs. Storing them correctly will help you complete the journey. Your enemies are heat, humidity, light, and chemical intrusion. You should also never store color and black-and-white materials in the same envelope or sleeve as some interaction may occur.

Materials made of polypropylene, polyethylene, and buffered acid-free paper are good for storing film and prints as are KODAK Storage Envelopes for Processed Film (available in 4 x 5 and 8 x 10-inch sizes). Although color materials often need to be frozen to prolong their life, the requirements for black-and-white materials are not so

stringent. So long as temperature does not exceed 70°F (21°C) and humidity is within 30-50%, black-and-white materials will fare well.

Unless you have access to a storage area prepared specially for photographic artifacts, you'll probably have to find a location in your house. Excessive humidity generally rules out the basement, although a dehumidifier could make it acceptable (don't let the humidity creep up though). Excessive heat makes the attic a definite no. The first floor of a house is usually cooler than the second. So you'll likely choose a space in your living or dining room. Because dresser drawers and buffet shelves and cupboards give off fumes from glues and wood resins (and have little air circulation), they aren't good storage areas.

Probably the best location is on the floor (make that a shelf if you have kids) of an open closet or atop a piece of furniture. In either instance, your prints and negatives should be placed inside the materials described above and then placed inside a storage box appropriate for photographic materials.

*One of the many advantages of heat drying is that your dried prints are flat. For best performance from your paper, check to see if there are any specific instructions for heat drying, processing, and toning. Adequate washing before drying and a clean dryer belt will help avoid chemical contamination—the foremost enemy of photographic products.*

Tom Beelmann

87

Martin L. Taylor

## TONING PRINTS

Toning is a post-wash chemical treatment for black-and-white prints that usually (but not always) alters the color of the image. There are three basic reasons for toning:

1. Enhance the appearance of the print by changing the image color;
2. Enhance the lasting quality of the image by protecting the silver image from attack by airborne pollutants;
3. Increase the density of the blacks in the print without significantly changing image color.

### Aesthetic Considerations

Many photographic papers exhibit an inherent image tone that viewers find particularly appropriate for certain kinds of subjects. Traditionally, warm-tone papers are favored for portraiture or pictures meant to convey a mood of warmth or coziness. Neutral or cold-tone papers are often chosen for commercial subjects, architecture, winter scenes—generally, pictures that gain effect by projecting

an impression of coolness and hard-edged precision. By using toners you can adjust the image color of many papers, exaggerating or reducing it.

### Prepared Toners

The most convenient approach to toning is to use a product that is ready to mix or dilute as purchased. The following KODAK Toners are readily available from photo dealers.

KODAK Brown Toner produces warm brown tones when used with papers that feature a neutral black image tone. KODAK POLY-TONER produces reddish brown to very warm brown tones, depending on dilution, on papers with image tones ranging from neutral to warm. KODAK Rapid Selenium Toner produces various hues of cold browns and cold blacks according to dilution, and is recommended for papers with warm-black and brown-black image tones. KODAK Sepia Toner gives warm brown tones with cold-tone papers or yellowish-brown tones with warm-tone papers.

### Using Toners

It's important to plan ahead. Use a compatible toner and paper combination. Not all toners work well with all papers. Some toners change image density and/or contrast. Expose and develop prints with these changes in mind. Fix prints in fresh fixer for no longer than the recommended time. If possible, use two-bath fixing. Exhausted fixer and prolonged fixing time can cause inconsistent and uneven toning. Thoroughly wash prints that are to be toned. Insufficiently washed prints may show off-colors, stains, or mottling after toning.

Carefully follow toner directions. Some toners are adversely affected by metal, so don't use metal graduates, trays, or other darkroom implements. If you use enamel trays, check to see that the toner can't reach metal through chips or cracks. It is easier to judge the image color if you tone prints in a white tray. To monitor toning progress effectively, do it in a well-lighted area. Subtle changes are hard to see in poor light.

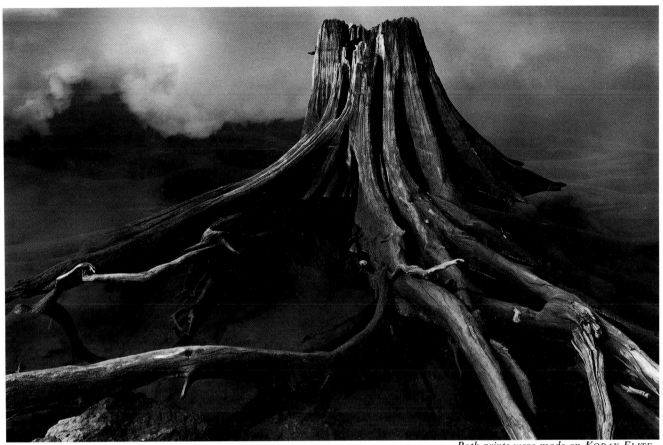

Scott Griswold, Jr.

*Both prints were made on KODAK ELITE Fine-Art Paper and toned in KODAK Rapid Selenium Toner at a dilution of 1:20. Such a dilution helps protect the print from atmospheric contaminants and increases the D-max for even richer blacks.*

Toning is not a totally predictable, precisely controllable process. Variations in print exposure, development, fixing, and washing can cause noticeable print-to-print differences after toning. If you wish to make several virtually identical prints, expose and process them in a single production run and tone them simultaneously in the same tray, if possible. The effect of some toners builds slightly, even after you've removed the print from the solution. Experience will teach you when to stop the process to attain the image color you want.

With some combinations of papers and toners, heat-drying may cause further changes in image color, and not always in a desired direction. Such changes can be avoided or at least minimized by using the lowest temperature setting that dries the paper adequately. Also avoid excessive temperature when hot-mounting toned prints. When spotting or retouching toned prints, remember that it may be necessary to alter the color blend of the dyes you normally use.

## TONING CLASSIFICATION CHART

| Papers | Developer or Process | KODAK Toners | | | | | | | |
|---|---|---|---|---|---|---|---|---|---|
| | | POLY | | | Brown | Sepia | Selenium | | |
| | | 1:4 | 1:24 | 1:50 | | | 1:3 | 1:9 | 1:20† |
| POLYFIBER™ | DEKTOL | S | M | M | F | F | M | M | N |
| POLYPRINT RC | DEKTOL | S | M | M | M | F | S | N | N |
| EKTALURE | SELECTOL | F | F | F | F | F | F | F | — |
| KODABROMIDE F2* | DEKTOL | N | S | S | S | F | N | N | — |
| ELITE | DEKTOL | M | M | M | F | F | S | S | VS |
| POLYCONTRAST Rapid II RC F | DEKTOL | N | S | S | F | F | S | S | N |
| | RPP | N | S | S | M | F | S | N | N |
| KODABROME II RC 2 | DEKTOL | S | M | M | F | F | N | N | — |
| | RPP | N | S | S | M | F | N | N | — |
| PANALURE F | DEKTOL | N | S | S | F | F | N | N | — |
| PANALURE II RC | DEKTOL | S | M | M | M | F | S | S | — |
| | RPP | S | S | S | M | F | N | N | — |
| Mural | SELECTOL | M | M | F | F | F | M | M | — |

N  No Tone Change
VS  Very Slight Tone Change
S  Slight Tone Change
M  Moderate Tone Change
F  Full Tone Change
RPP  Processed in the KODAK ROYALPRINT Processor, Model 417
214  Processed in the KODAK EKTAMATIC Processor, Model 214

\* Other contrast may produce slightly different tone changes.

† Dilution normally used for extra image stability or to increase D-max.

When toning to change the image color, you may want to experiment. Different papers react differently to toners, and your favorite paper may not be the best one to give the image color you want.

POLYFIBER Paper developed in DEKTOL Developer, diluted 1:2; untoned.

Tom Beelmann

POLYFIBER Paper developed in DEKTOL Developer, diluted 1:2; toned for 17 minutes at 70°F (21°C) in KODAK Brown Toner.

POLYFIBER Paper developed in DEKTOL Developer, diluted 1:2; toned in KODAK Sepia Toner according to package instructions.

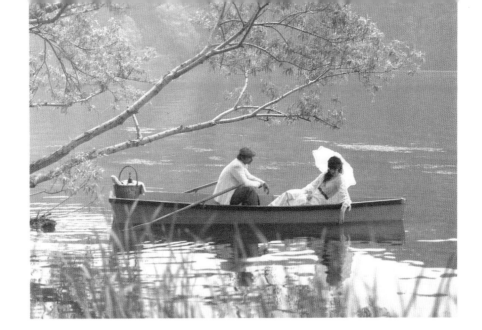

*EKTALURE Paper developed in SELECTOL Developer, diluted 1:1; untoned.*

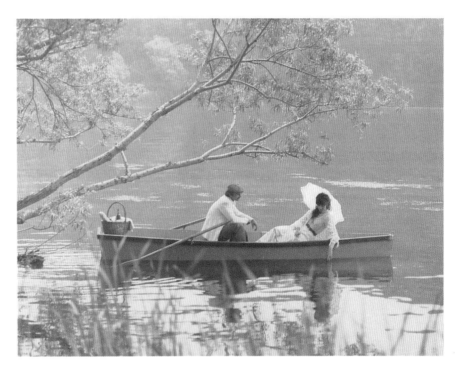

*EKTALURE Paper developed in SELECTOL Developer, diluted 1:1; toned for 7 minutes at 70°F (21°C) in KODAK POLY-TONER, diluted 1:50.*

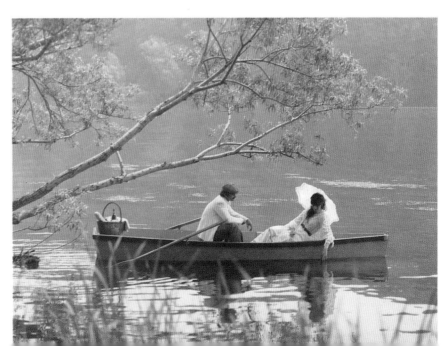

*EKTALURE Paper developed in SELECTOL Developer, diluted 1:1; toned for 6 minutes at 70°F (21°C) in KODAK Rapid Selenium Toner, diluted 1:3.*

Tom Beelmann

Mounting with heat is preferred by many photographers because several factors contribute to protecting the print. First, the adhesive tissue acts as a barrier to help prevent migration of harmful substances from the mounting board into the back of the print. Second, heat mounting is very effective in bonding the print to the mount board. Among the disadvantages of heat mounting are the high cost of the press and the hazard of overheating a print.

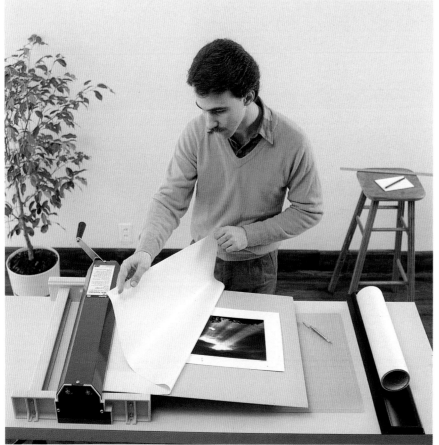

Tom Beelmann

Cold mounting procedures are relatively new, but they seem to perform well at holding the print on the board. Whether they protect a print as well for long-term keeping remains to be seen. Mounting of any kind helps to protect the edges and corner of the print. It also keeps the print flat for optimum viewing. Many museums and galleries now refuse to look at work that is not board-mounted.

## MOUNTING PRINTS

Mounted prints survive minor mishandling better than unmounted ones and lie flatter. And because they feel more substantial, they may be perceived as more valuable than identical prints that are unmounted.

### Mounting Methods

You can mount prints in a press with heat-activated bonding materials or you can use cold-mounting techniques that employ adhesives. Some cold-mount processes require applying heavy pressure with rollers or a press to create a strong bond. Others do not. Most mounting methods are permanent. Even when they aren't, there is usually considerable risk of damaging the print during removal.

Most bonding media supplied specifically for mounting photographs are claimed not to cause or accelerate deterioration of the print. Nonetheless, many photographers concerned with print longevity favor dry mounting in a heated press. They also mount prints only on conservation quality mounting boards or other backing materials of known safety.

### Flush Mounting

Flush mounting, in which the mounting board does not extend beyond the print, is quick to do but doesn't provide much protection to the edges of the image. It is most useful for prints that are to be displayed temporarily or informally without frames or in simple gallery-style frames. The easiest way to flush-mount a print is to mount it untrimmed on a slightly oversize board, then trim print and mount simultaneously with a sharp mat knife or razor blade and metal straightedge or with a heavy-duty cutter.

### Mounting with a Border

Mounting a print so that the mount board forms a pleasing border takes more time than flush mounting but produces a more impressive effect. A good rule of thumb for positioning the print on the backing is to use equal-width borders at left and right, and a bottom border about 25 percent deeper than the top border. A T-square with ruler-calibrated edges helps position the print accurately. When dry-mounting, simultaneously trim the print and attached mounting tissue to final size before bonding them to the backing. As a rule to which there are occasional exceptions, simple white, gray, or black borders look best.

*When handling prints, make sure that your hands are freshly washed and devoid of skin cream or other topical preparations. Unless you are as fastidious as this fellow, consider wearing clean cotton gloves to keep hands where they belong—away from the print.*

Tom Beelmann

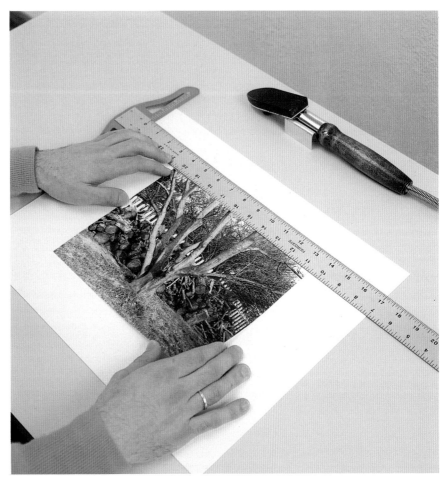

John Menihan

## MATTING, FRAMING AND DISPLAYING PRINTS

One of the pleasures of photography is sharing your vision. Although a fine photograph will be appeciated for itself, the way you present it may enhance the total effect. Just as attractive presentation seems to improve the taste of good food, tasteful matting, framing, and display can improve good photographs.

### Matting Prints

Overmats serve two basic functions: they isolate images from irrelevant surroundings by providing a neutral or complementary field, and they prevent the surface of a framed print from contacting the cover glass. Precut mats are available with image apertures in a variety of standard sizes. If you wish to use them, print so that the image areas you want to show will fit the precut apertures.

You can also prepare overmats yourself by cutting thin mounts or mat boards to whatever dimensions you prefer. Handheld mat cutters, available from art supply stores, facilitate making clean, uniformly beveled cuts. Follow instructions carefully and practice on scrap until you master the technique. Use conservation-quality mat boards if you are

concerned about extended image life.

Plain white mats go well with most black-and-white pictures. There is often some choice in the range of white tones. You may prefer to match the tone of your mat board to the tone of your paper base. Gray and black mats also suit a broad range of photographs. Colored mats occasionally work well with specific images but can pose problems if you attempt to display several prints with different-colored mats in the same area.

### Framing

There are two broad categories of frames: simple, gallery-style frames that provide neat, unobtrusive protection for pictures; and more elaborate, sometimes ornate, frames that are meant to embellish the picture

John Menihan

and function as part of the room décor. Gallery frames can be used with almost any subject and photographic style. Décor frames must be used with discretion. For example, a bold, stark rendition of an industrial scene or a modern building would look silly in a rococo gilt frame that might be an excellent setting for a formal portait.

When you print a picture you intend to frame, enlarge it to a size that will fit comfortably within the frame. It's easier to print for the frame than to try to find a frame to fit an odd-size picture. If you wish to use an over-mat, allow for it.

For image stability, use only conservation-quality mats and backing, and avoid frames made of materials known to emit vapors that cause image deterioration. Glass, metal, and some plastics are considered safe.

You can make or assemble gallery frames quickly and easily from kits or stock parts available through art supply dealers, framers, and department stores. If you're handy with tools, you can also make décor style frames. If not, they are sold through frame shops and other retail outlets, custom-made or in standard designs. Make sure an elaborate frame harmonizes both with the photograph and the area in which it is to be displayed.

### Displaying Photographs

Where and how you display photographs are matters of personal taste, but do consider the ambient lighting before reaching for the picture hooks. Hang pictures where they can be seen properly. A predominantly dark picture may be difficult to decipher in a dim area yet be perfectly "readable"

in brighter surroundings. A photograph that looks too light in a bright part of a room may look just right in a darker spot. When you print for display, try to visit the display area first. Then you can tailor-print the density to suit lighting conditions.

Lighting quality and direction are important in displaying photographs. Hang pictures to avoid surface glare that can make proper viewing difficult. High-gloss prints are notoriously hard to display without picking up specular reflections. Smooth and matte finishes are easier to hang in glare-prone environments.

Finally, consider size. Pictures that must be viewed at a distance should be printed larger than those that are approachable. In preparing pictures for display, as in other aspects of photography, it pays to plan ahead.

# Index